Fantasy Art for Beginners

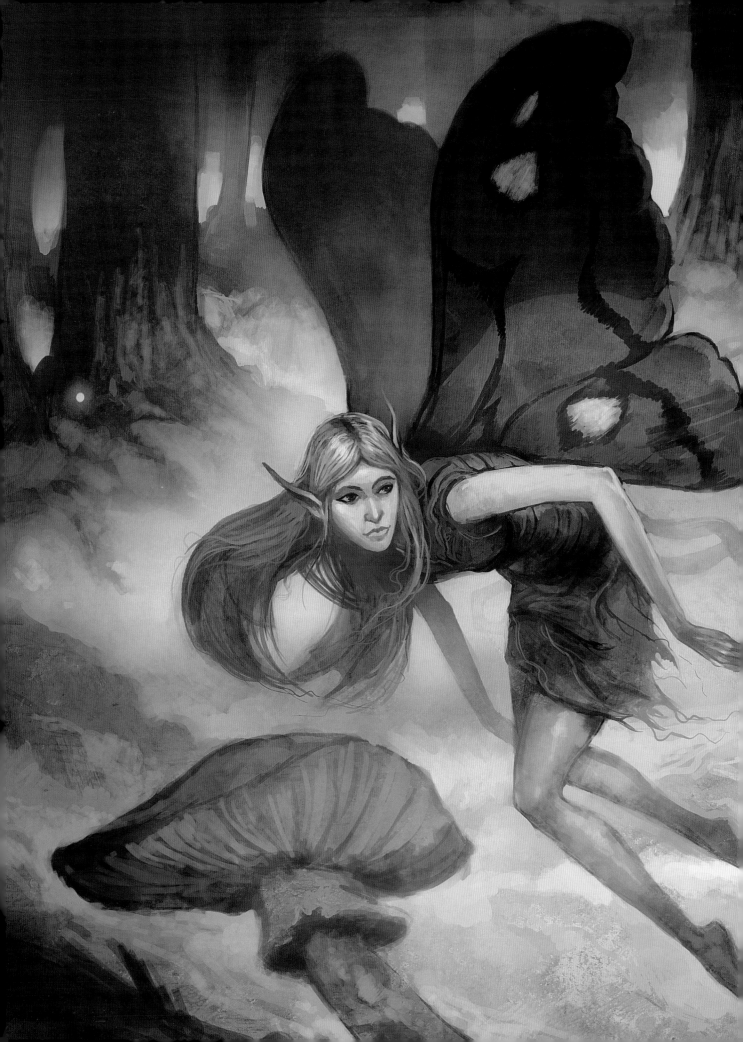

Fantasy Art for Beginners

Create fantasy beings STEP-BY-STEP

Jon Hodgson

IMPACT

for Nina and Rory

A DAVID & CHARLES BOOK
Copyright © David & Charles Limited 2009

David & Charles is an F+W Media Inc. company
4700 East Galbraith Road
Cincinnati, OH 45236

First published in the UK in 2009

Jon Hodgson has asserted his right to be identified as author of this work in accordance with the Copyright, Designs and Patents Act, 1988.

A catalogue record for this book is available from the British Library.

ISBN-13: 978-1-60061-342-5 paperback
ISBN-10: 1-60061-342-x paperback

Printed in China by RR Donnelley
for David & Charles
Brunel House Newton Abbot Devon

Senior Commissioning Editor: Freya Dangerfield
Editorial Manager: Emily Pitcher
Editorial Assistant: James Brooks
Project Editor: Ame Verso
Designer: Joanna Ley
Production Controller: Kelly Smith
Indexer: Lisa Footitt

Visit our website at www.davidandcharles.co.uk

David & Charles books are available from all good bookshops; alternatively you can contact our Orderlineon 0870 9908222 or write to us at FREEPOST EX2 110, D&C Direct, Newton Abbot, TQ12 4ZZ (no stamp required UK only); US customers call 800-289-0963 and Canadian customers call 800-840-5220.

PICTURE CREDITS

All images © Jon Hodgson with the exception of:
p22 'Dragon Warriors' © 2008 Jon Hodgson and Magnum Opus Press.
p23 'Sleeping Gods' © 2008 Jon Hodgson and Magnum Opus Press.

p24 'Void Shugenja' © 2007 Alderac Entertainment Group, used with kind permission.
p27 'Dragon Warriors Bestiary', 'The Elven Crystals' © 2008 Jon Hodgson and Magnum Opus Press.
p30 'Scroll Sage' © 2007 Alderac Entertainment Group used with kind permission.

Contents

Part 2

Introduction

Fantasy art is the art of the imaginative, the mythic, the legendary, the wonderful and the sublime. It has a rich history reaching back to the origins of art itself, as our ancestors crouched in darkened spaces to paint images on cave walls of the animals they wished to hunt. Ever since that time, artists have been inspired to paint from their imagination, with varying degrees of popularity and public acceptance through the ages.

Today, fantasy is a widespread genre and fantasy art is more popular than ever, appearing in films, novels, online games, console games, card and miniatures games, comics, animations and a host of other formats – in short, we can see fantasy art all around us.

So it is that many budding artists come to take up a pencil, brush or tablet stylus and embark on the epic journey of becoming a fantasy artist. This can be a frustrating time for many, as they discover the route to drawing and painting the imaginative vistas of their mind's eye is fraught with unexpected pitfalls. Like any would-be artist we all soon encounter our own shortcomings, the huge obstacles we have to climb, and an impenetrable wall of jargon that can, at times, seem more to hinder our progress than help it.

This book is designed to make the process easier. Not only does it walk through some of the most basic elements required to make fantasy art, it also explodes much of the jargon into more beginner-friendly terms, and shows you the more elementary steps that are often missing from other 'How To' guides.

WHAT IS FANTASY ART?

Fantasy art is a broad category that can mean many things. By and large, when we talk about fantasy art, we mean art that depicts things as we see them around us but in the setting of a fictional world, which often has elements of the supernatural, magical, strange and enchanting. Fantasy is closely connected to myth and legend, and can very often have a folkloric or historic element. In Western countries, fantasy is often medieval in nature, or from earlier pre-Christian times, such as 'Celtic'.

Fantasy art is also closely tied to fantasy literature, and so the work of JRR Tolkien, CS Lewis, Robert E Howard, Michael Moorcock, Philip Pullman, JK Rowling and many more can give us the defining characteristics of the genre.

In fantasy we typically see monsters, dragons, wizards and witches, sword-swinging heroes and heroines clad in armour, castles on impossibly high mountain crags, and deep, dark forests full of strange and fearful creatures. It's like history but better – it's the grand tale of adventure, the quest for glory and treasure, or the secret knowledge of magic. The themes in fantasy have always been the struggle between good and evil, coming of age and the protagonist's personal journey. Fantasy art is about exploring strange worlds that we recognize more in our hearts than in our heads.

CREATING FANTASY IMAGES

Anything is possible in fantasy art, which gives us great freedom to draw and paint whatever we choose. But to really engage the viewer – to make a believable fantasy that suspends our natural disbelief in flying carpets and half-man half-bull creatures – takes some artistic skill. Reading fantasy literature and looking at the work of great fantasy artists (see box, opposite) can be very inspiring, but it can also be quite daunting. The fear of failing can be enough to put us off before we even pick up a pencil for the first time.

But fear not. As this book shows, all fantasy art can be broken down into simple, understandable steps, which, with dedication and practice can be mastered – or at least made to feel a bit less unfamiliar. This book gives you the basics as stepping stones to your own development. With a few sound principles you can work on, simply and clearly explained and demonstrated, there should be no stopping you.

Before we go any further, a word of warning to those still keen to embark on such a perilous quest! This book will help you find your feet, perhaps even strap your boots on, but it is you who must take the first steps, and you who must find the strength to continue on the path. For be warned, the road is long and hard, and only those who are truly determined will succeed. There are no shortcuts – only hard work and dedication will see you progress on the trail of fantasy art.

Roll for Initiative ▶
A doughty band of adventurers encounter the tower guardian – a classic struggle between heroes and monsters. This image was created digitally using Corel Painter software (see page 13).

Great fantasy artists past and present

Fantasy art has existed since the earliest civilizations – from the deities of Egyptian, Greek and Roman cultures, to the magical beasts of medieval art, from the Romantics to the Pre-Raphaelites.

The following list of names merely scratches the surface of the thousands of fantasy artists that you can research to seek inspiration for your own art.

William Blake	Jon Foster	Jeffrey Jones	Katsuhiro Otomo
John Blanche	Frank Frazetta	Alan Lee	Viktor Vasnetsov
Paul Bonner	Brian Froud	Todd Lockwood	John William Waterhouse
Jeff Easley	Akseli Gallen-Kallela	Ian Miller	Michael Whelan
Larry Elmore	John Howe	Terese Nielsen	Berni Wrightson

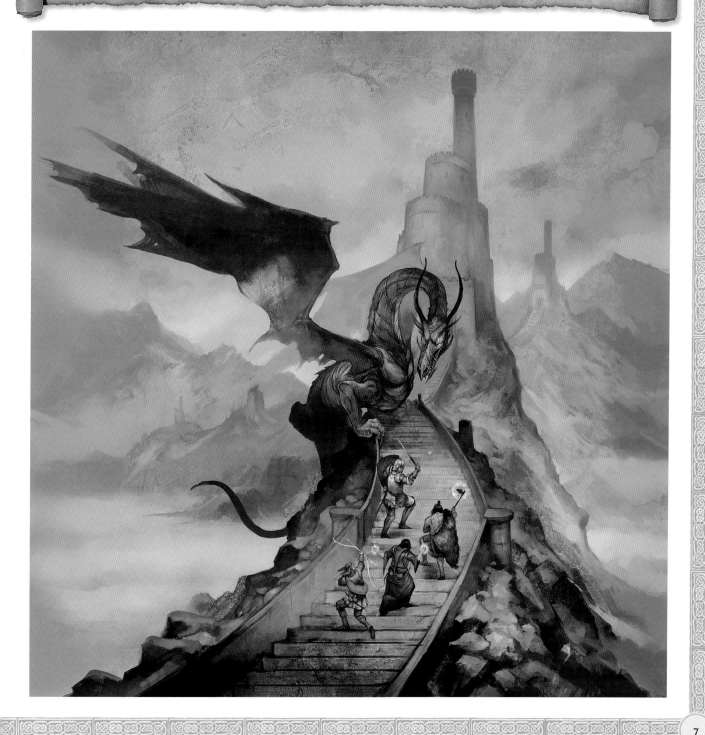

How to Use This Book

This book is divided into two parts. The first part is the theory section, telling you all about different tools, media and techniques. It covers drawing, painting, composition, colour and lighting. While you can dip in and out, it is well worth reading it in its entirety to get a good, solid foundation.

With the theory safely under your belt, the second part of the book shows you how to draw and paint six different fantasy art archetypes in full step-by-step detail. As well as lots of useful hints and tips, each painting also has an example of how a professional artist might take the image further, which you will hopefully find very inspiring.

Throughout the book there are examples and diagrams created specifically to illustrate the text. There are also a number of paintings from my own back catalogue, which show the techniques in a practical context.

ADVICE TO ARTISTS

The underlying principle of this book is that with practice and a little study anyone can learn to draw and paint. Of course, some people seem to have a greater aptitude for it than others, but I have seen enough would-be artists fall by the wayside more through lack of perseverance than through lack of talent. So keep at it, take breaks, dip in and out, and above all don't beat yourself up. Fantasy art can inspire all kinds of emotions but there is almost always an element of wonder and sheer fun to it – so don't lose sight of that!

Some of the sections that follow might take repeated readings over a period of time to sink in. Twenty years on, I still think back to things one great teacher told me, and some of these things I still don't fully understand! So take heart if particular sections don't immediately make sense. Sometimes you need to be a little further along the path to get the wider view. Some topics covered later could (and do) fill whole volumes on their own, so many aspects of drawing and painting have been summarized to get you started.

Finally, please bear in mind that no book can teach you how to draw or paint. This book can point the way, but it is no more than a signpost. The journey itself belongs to you, and only you will make it the great voyage it can become.

Three keys to success

There are three things that are vital for learning to draw and paint. The first and most obvious is the practical application of techniques – actually drawing and painting. Practice is the key to becoming a proficient fantasy artist – there is no shortcut. There's a saying that every artist has a thousand bad drawings in them before they get to the good ones. It's a long journey but at least it's a fun one!

The second thing, which can sound daunting or even boring, is art theory. Many beginners fear that learning art theory will be as much of a challenge as studying astrophysics but, in fact, you probably already know some art theory. You know that red

and blue make purple, right? Well, that's colour theory! When learning to draw and paint it is important to study the rules, laws and guidelines. As well as following the path step by step, you need to consult a map once in a while to understand where you are going, and why the path is going so steeply uphill.

The third thing is taking inspiration from working artists, be they lowly commercial illustrators like myself, or the great masters of the Renaissance. On your journey it helps to know the landmarks of the territory you find yourself in. No one creates work in a vacuum, and all artists are rightly inspired by each other's work.

Simple, jargon-free text explains the crux of each subject area.

Example illustrations reveal how to put the techniques into practice.

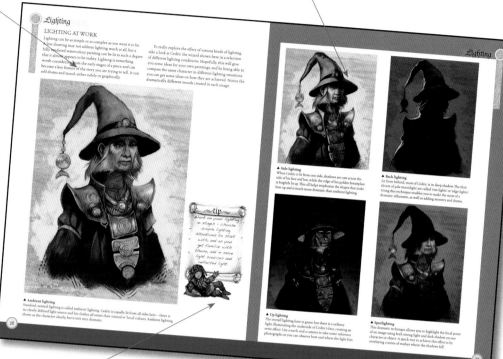

Helpful, bite-size tips give you further insight and food for thought.

Clear images show you how to build up the painting one step at a time.

Detailed instructions are given for every step of the process.

~ Part 1 ~

The first part of the book reveals the different tools, media and techniques you need to set off on your fantasy art quest. From traditional supplies and skills to computer paraphernalia and processes, as well as general advice on composition, colour and lighting – this part will give you a solid foundation on which to begin your journey.

Traditional Media

'Traditional' refers to real paints, pencils and crayons applied by hand to paper or canvas, as opposed to 'digital' tools, which exist only in a computer. There are hundreds of different kinds of traditional media, some easier to come by than others. This section focuses on the more straightforward things you will need to get started.

PENCILS

The simplest and most easily obtainable of drawing tools, pencils come in a variety of types, ranging from hard and faint 8H to soft and messy 8B. A sharp HB is perfectly adequate for the purposes of this book.

Advantages: Cheap, readily available, erasable, reworkable, portable, wonderful varied marks.

Disadvantages: Monochromatic (grey), needs sharpening.

BALL-POINT PENS

Often overlooked as a drawing tool, ball-point pens can make fine drawings. You can find them in every household and they only cost a few pennies to buy.

Advantages: Cheap, accessible, you are already experienced at using one, nice quality of tone.

Disadvantages: Ink never dries making storage difficult, easily smudged, hard to make a great variety of marks.

ACRYLIC PAINTS

Available in pots or tubes, acrylics are widely accessible and affordable. Acrylic paint is quite easy to understand and many people learn how to use it at school. It can be used 'neat' as opaque paint or diluted with water for a wash (see page 19).
Advantages: Fast drying, largely non-toxic, reasonably priced, water-soluble, very versatile.
Disadvantages: Can be unforgiving, colours can be chalky, can be hard to blend.

OIL PAINTS

Oils come in tubes and require technical know-how to use successfully. Oil dries very slowly and needs careful application with varying amounts of thinners used as the painting progresses to ensure a stable result.
Advantages: Great colours, amazing blending.
Disadvantages: Thinners can often be toxic, technical process required, can be difficult to use, can be expensive.

WATERCOLOUR PAINTS

Watercolours come in tubes or blocks. They are easy to mix and apply, but you cannot heavily rework watercolours once they are laid down, as they always remain water-soluble.
Advantages: Delicate colours, water-soluble, great for washes.
Disadvantages: Can be hard to rework, unforgiving, paintings can be fragile.

PAPER

There are thousands of varieties of paper, from the cheapest flimsiest newsprint to the heaviest and most expensive rag watercolour paper. Try out different kinds to see what you like. Simple copier paper is excellent for sketches.
Advantages: Easy to obtain, cheap, wide choice, easy to scan.
Disadvantages: Can buckle or 'cobble' with too much water, very fragile.

CANVAS

An artist's canvas is a wooden frame with fabric stretched tightly over it. You can buy canvas pre-stretched from the art store, or you can do it yourself at home. Canvases are very light and quite strong.
Advantages: Very easy to display, lightweight, great if you want to sell your images.
Disadvantages: Can be time-consuming to prepare, if bought is a fixed size, can be expensive, can be daunting to work on, difficult to scan.

ILLUSTRATION BOARD

Also referred to as Bristol board, this material comes in large sheets from the art store. It is a compressed, very smooth kind of cardboard that provides a nice versatile surface to work on.
Advantages: Lightweight, relatively inexpensive, good smooth surface, easily cut to shape, easy to scan.
Disadvantages: Can be fragile, can warp.

Digital Tools

Digital painting – making a painted-style artwork on a computer – is becoming increasingly popular. There are numerous websites and magazines devoted to this field. With software becoming ever cheaper, graphics tablets becoming more readily available and people generally being more computer literate, digital painting is experiencing a real boom.

COMPUTER

The kind of computer you use comes down to two options: PC or Mac, but there is no real difference between the two for making digital artwork – it is purely a personal preference. The main thing to think about is memory (RAM). Digital painting can create big files, so lots of RAM is vital to smooth working. New computers increasingly come loaded with large amounts of RAM, but if you're using an older machine make sure you have plenty.

INPUT DEVICE

Mouse or tablet? There are some successful digital artists using nothing beyond the mouse that came with their PC. Most, however, choose to use a graphics tablet – a plastic board connected via a USB cable with a wireless 'stylus' pen. What you draw on the tablet comes out on the screen. The better models have very fine pressure sensitivity so that marks can be incredibly varied. When acquiring a graphics tablet, the more you spend the better. However, you can make very nice work on the reasonably priced entry-level models.

SOFTWARE

There are a wide variety of programs that can be used to make digital art. These are the main ones:

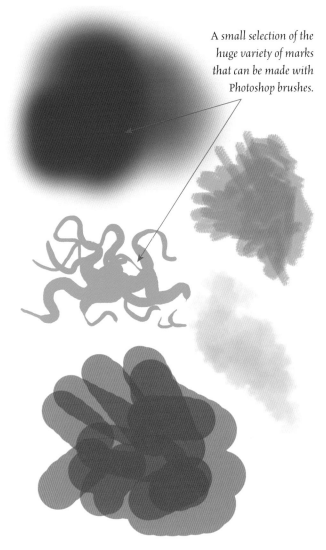

A small selection of the huge variety of marks that can be made with Photoshop brushes.

ADOBE PHOTOSHOP

The mainstay of most digital art, Photoshop is the big boy in the playground. Hugely versatile and enormously powerful, Photoshop is much more than a photo-editing program.

Advantages: Tremendously powerful, well tried and tested, widely used.

Disadvantages: Amazingly expensive, a lot to learn which can seem impossible, easy to fall back on clichéd effects.

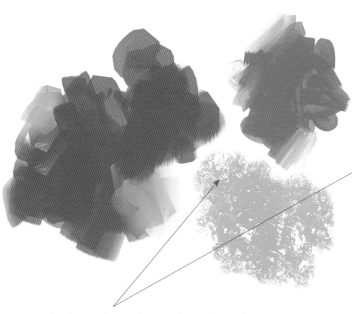

Painter brushes are designed to simulate traditional media such as chalks, oil pastels and acrylics.

COREL PAINTER

Painter is a piece of software that is geared towards replicating traditional media rather than image editing and fine-tuning. The program has an enormous selection of brushes that emulate real media like oil paint, charcoal and acrylics.

Advantages: Amazing simulation of real media, great blending, really good oil paints, loads of preset materials, great textures.

Disadvantages: User interface can be off-putting, steep learning curve, requires traditional skills to get the best from it, far less image-editing functions than Photoshop.

~tip~

Adobe also produces a pared-down version of Photoshop called Elements, which offers the majority of the tools you need to get started but at a fraction of the cost.

AMBIENT DESIGN ARTRAGE

One of the smaller kids on the block, ArtRage is a very reasonably priced piece of software that punches way above its weight. It is great for very natural-looking media effects and awesome for underpainting.

Advantages: Cheaper than other programs, amazing paint emulation, simple interface.

Disadvantages: Not as versatile as other image-creation programs, can be hard to control for a beginner, need to 'Export' to save in more common image file formats.

OTHER SOFTWARE

GIMP – a free open source image editor, available online, which duplicates much of the functionality of Photoshop. Well worth a look.

Photopaint – a home-user level program that still has many features of more professional tools. It is inexpensive and a good place to dip your toes into digital art.

MS Paint – the 'painting' tool that comes bundled with every PC. Very basic, but it still works!

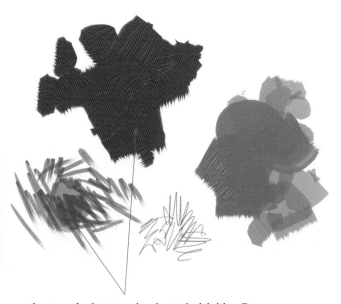

The strength of ArtRage brushes is the life-like effects and textures that can be created with genuine ease.

Drawing

Drawing is the most essential skill in fantasy art. If you can draw well, then you will be able to handle many other aspects of creating art much more easily. Drawing is the bones of the fantasy art beast – with strong bones you will have a powerful beast.

GETTING STARTED

For good drawing, you need to sit down somewhere comfortable with strong light. You need a solid surface to rest on – a drawing board, the kitchen table, a piece of hardboard on your lap, an easel or a hardback book – some paper and something to draw with – an HB pencil is ideal, but a ball-point pen will work too. If using a pencil, you may want to have an eraser to hand too.

Hold fast!
Learning how to hold a pencil properly to draw is very important. Drawing is not the same as writing – when you write you work in a tiny area with each letter, but when you draw you want to be able to work across the whole page in fluid motions – so it can help to change your pencil grip. Drawing movements need to come from as high up your arm as possible to give the maximum range of movements. Hold your pencil loosely and let your arm relax.

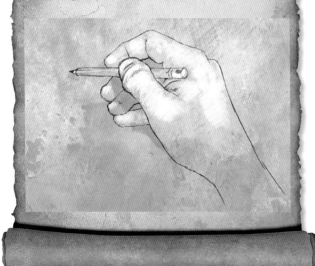

WARM-UP EXERCISES

Warming up before a drawing session can help you to get rid of tensions. Even though your ideas may be bursting to come out, a few exercises, performed regularly, can really improve your drawing.

Scribble exercise ▶
Scribble in as many different ways as you can – long lines, curly lines, sharp lines, stipples, wide marks with the edge of your pencil. Keep your arm nice and loose and practise keeping your hand off the page as much as possible to avoid making any smudges.

Line exercise ▶
Draw as many straight lines as you can – some long, some short, some fast, some slow. This is very hard at first because the muscles required to make a steady line will be weak but they will strengthen with practice.

Oval exercise ▶
Draw as many ovals as you can – making them even, smooth and the same at both ends. A circle seen in perspective is an oval and figures can be built up from ovals too, so you will draw more of these than you might at first think.

Tone exercise ▶
Try out different ways of covering the paper – hatching (see opposite), scribbling, little circles, continuous pencil lead, any way you can think of.

MARKS AND SHADING

A good drawing has a variety of marks: long fluid lines, sharp little marks and stipples, carefully shaded areas and energetic areas. Shading, or 'tone' as it is more properly called in art jargon, can be a daunting area of making fantasy art. The following examples reveal some different styles you can use.

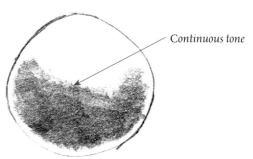
Continuous tone

▲ **Continuous tone**
With this technique the idea is to disguise the material you are using as much as possible. This is good for very realistic styles, but can be very time-consuming and hard to achieve.

A pencil can make a host of different marks so be sure to take advantage of this versatility. Think about how the marks and shading technique you use can show what you're trying to depict, be it flesh, rock, scales or fur.

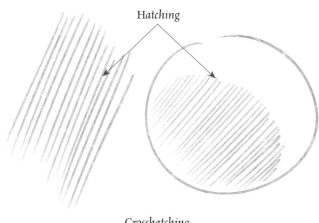
Hatching

▲ **Observational drawing**
Drawing from life is a vital skill. Always carry a sketchbook and draw what you see around you at every opportunity. Everything you need to make great fantasy art is out there in the real world: animals in the zoo, light coming through the clouds, an old man sitting on the bus – anything and everything will give you the chance to practise, and it will all feed your work.

Crosshatching

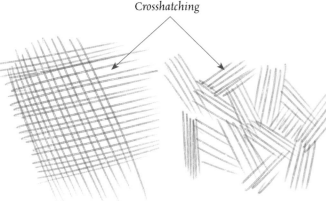

~tip~
Don't be in a rush to scrub out parts of your drawing with an eraser. Mistakes are how you learn. Use an eraser to tidy up construction lines, to 'lift out' white in shading, and very little else.

▲ **Hatching and Crosshatching**
These techniques use small lines to create a pattern to add tone. This can be quite stylized, which means not very realistic, but it is pleasing to the eye.

Drawing

CONSTRUCTING OBJECTS FROM BASIC SHAPES

The easiest way to begin a drawing is to start from basic shapes. As you gain experience, you will find it increasingly easy to break down objects into their constituent shapes. Start simply by blocking in the basic shapes and then work towards adding more and more detail on top. Diving right in for the details will only lead to frustration and unfinished drawings.

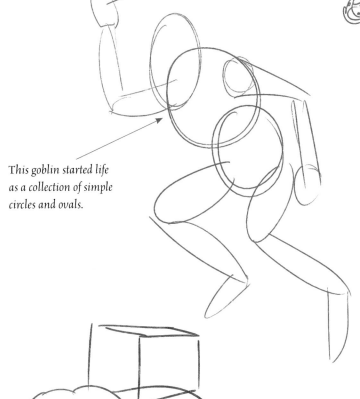

This goblin started life as a collection of simple circles and ovals.

The basic shapes are then worked over with attention to the more detailed shapes of the body parts and equipment.

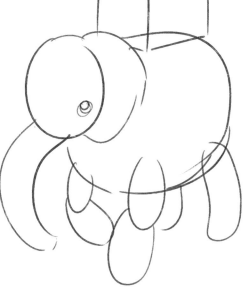

Even something as complex as a war-elephant starts as a series of circles, ovals and boxes.

▲ **Breaking it down**
All objects can be broken down into simple shapes. For example, when it comes to drawing figures the head is an egg shape. The torso can be drawn as a large oval. The arms and legs are tubes. Hands and feet can be placed as just boxes. Once you have these basic shapes down you can go on to refine them and add details.

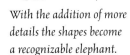

With the addition of more details the shapes become a recognizable elephant.

FIGURE PROPORTIONS

When drawing a figure, the first thing to be aware of is the 'proportions' or overall size of the figure. The unit of measurement we use for this is the head – people are made up of a number of head lengths. This is a very handy figure to learn. An average person is seven to seven-and-a-half heads tall. For fantasy art, we tend to use what are called 'heroic proportions', where the figure can be up to ten heads high, but usually eight to nine.

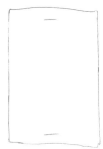

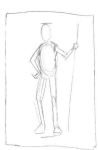

▼ Calculating proportions using heads

As this illustration shows, the size of the head is the same within most figures, regardless of height, so it makes a useful measuring tool. In order to extend the proportions, every other part of the figure is enlarged slightly, resulting in a more impressive stature.

▲ Fit the drawing to the page

Nothing looks worse than a drawing where you run out of paper. Always have one eye on how much room you need. Make a quick mark for the extremities of what you're drawing. For a figure, this will be the top of the head and the bottom of the feet.

This shorter figure is seven heads high, like a real-life person. This can appear a little squat, or large headed in a piece of artwork.

This figure is almost eight heads high and looks far mightier for it. It isn't necessarily realistic but it looks better in a fantasy image.

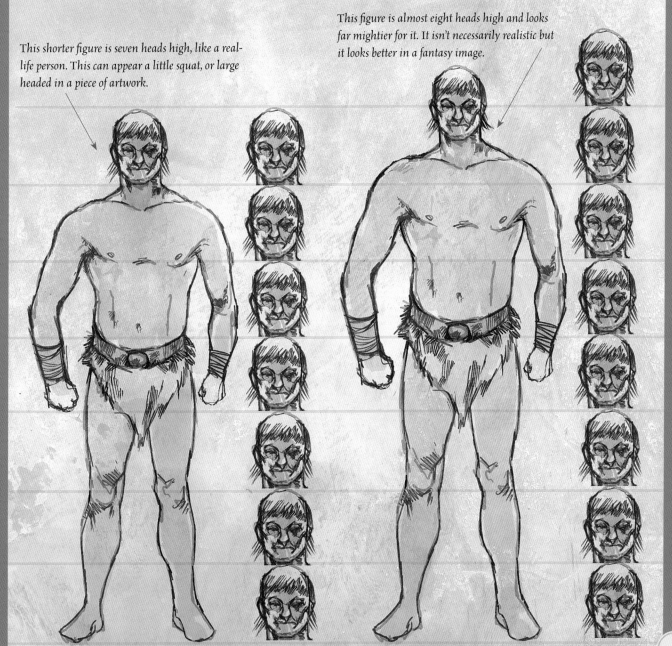

Traditional Painting

Painting is a challenge for most beginners. The best way to learn is to experiment and make mistakes. If you learn a tiny amount from every mistake then you are making progress. This section cannot teach you how to paint, but it does give you some basic guidance on starting out, mixing and applying paint to your paper, board or canvas.

START OUT RIGHT

Work in a comfortable and well-ordered environment. Organize your tools and look after them carefully. You cannot make good work with broken or poorly maintained tools. Make sure you have a stable surface to work on and arrange your workspace so that your support is angled upwards – working on a flat surface can lead to distorted images when you lift them off the horizontal.

BRUSHES

Choosing brushes can seem bewildering but the secret is to experiment. Sable brushes are wonderful to work with. Hogshair brushes are very coarse and are great for scrubbing on almost-dry paint or laying down big textural areas. Flat brushes are good for graphic marks and fan brushes can be used to blend colours delicately. To start with, just three round brushes – large, medium and small – should be sufficient. When you have finished painting, wash your brushes thoroughly and store them away carefully.

MIX IT UP

Mixing colours takes practice, thought and care. If you rush to keep adding in different colours you will quickly make a dirty brown. Use a large palette and clean it regularly. Use one brush to mix paint on your palette and a separate selection of brushes to take the paint to your painting.

There is a correct consistency to any paint that you mix. Paint that is too thin can soak in too much or quickly spread out of your control. Paint that is too thick can clog up your brush and go on in big lumps that are hard to work over. However, there are times when you want very thin paint, for example when making washes. Equally, big brush marks

of really thick paint (called 'impasto') can give wonderful effects. When mixing, think carefully about whether the paint is the right consistency for what you are trying to do.

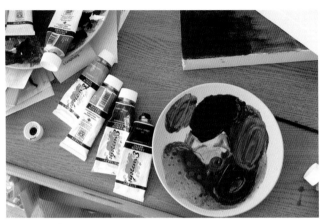

▲ **Paint palette**
You don't need specialist equipment for mixing paints. Try using an old dinner plate as your palette – its large mixing area and easily washable surface make it ideal for the job.

WASHES

When you want to cover big areas with dilute colour you need to use a 'wash'. This doesn't obliterate what is underneath, but slightly tints it to be more like the colour of the wash. Washes can be layered up one after the other to create deeper and deeper transparent colour, but it is vital to let each wash dry before adding the next one. With acrylics or watercolours, water is used to thin down the paint for washes but with oils, turpentine is used.

~tip~

Rather than trying to control everything in a painting, let 'happy accidents' occur and work with them. Learning to paint is about discovering how to work with the medium, not forcing it to obey.

MARKS

When applying paint, think about the marks and shapes you make with your brush. Do you want to totally cover up what's underneath, be it white paper or underlying colours, or do you want to let some show through? There is an endless variety of marks that can be used to help describe what you are painting; a rusty piece of armour might need a rougher, more textural approach than a wave on the sea, for example.

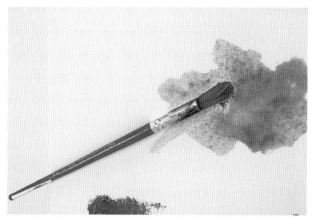

Wash ▶
A large, soft brush can push washes around very smoothly. A loose wrist lets the paint flow evenly.

▲ Wet on wet
Marks made with wet paint on wet canvas have soft edges, which spread out or 'feather'. This can create softer areas or texture. Clever use of these kinds of naturally occurring features of paint ensures you are working with the medium rather than against it.

▲ Thin paint
Thin paint laid down on canvas has lots of texture and movement. You can use the trails left by bristles to describe 3D shapes, just like pencil lines, giving your work life and depth. Using a combination of thin and thick paint adds visual interest to an image.

▲ Texture
Thicker application of paint adds real texture. It can be hard to work over, so use with care! Always think carefully about areas that would work best with a heavy texture. Rocks, corroded metal and monster skin, for example, work well with heavy, textural paint.

▲ Processes
In this image of a painting in progress, you can see a mixture of washes and paint applied with an almost dry brush, as well as a build up of semi-opaque marks. You can still see the orange primed canvas peeping through in many places.

Digital Painting

Digital media offer so many choices that there are countless ways to work. The method will depend on your chosen software (see pages 12–13), so you need to refer to your manual to understand how the specific tools function. However, this section reveals the basics of brushes, layers, blending and resolution to help you start out.

BRUSHES

The choice of digital brushes is overwhelming, but making a good digital painting is not in the brushes – it's in how you use them. You can make wonderful fantasy art with the simplest hard, round brush in Photoshop, or the most basic acrylic brush in Painter. In many ways, the simpler you start out the better.

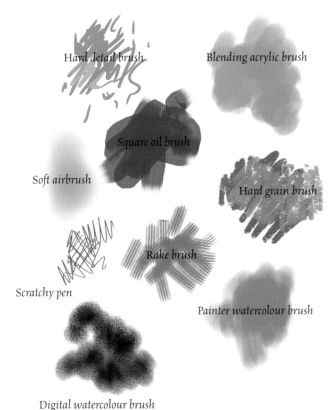

Hard detail brush

Blending acrylic brush

Square oil brush

Soft airbrush

Hard grain brush

Rake brush

Scratchy pen

Painter watercolour brush

Digital watercolour brush

▲ **Painter marks**
Painter brushes are very good a mimicking traditional brushes and a wide variety of marks is possible.

Medium-opacity round brush

Soft round brush

Medium-opacity textured nib

Custom nib

Custom nib

Custom nib

Custom nib

▲ **Photoshop marks**
Photoshop's brushes can be customized for your precise needs, making the variety practically endless.

HARD OR SOFT?

In most digital painting programs, you can control how hard or soft your brush is and it is important to choose the right tool for the job. Details require a harder, smaller brush than distant backgrounds. In a single painting you should have both soft and hard marks. For example, in a landscape clouds are soft and hazy, whereas rocks are hard and textured. Always think about what it is you are painting and choose the brush accordingly. Spend some time experimenting with your software and make notes about which brushes are suited to which tasks.

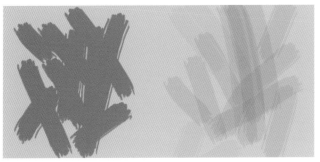

High opacity – *the marks are opaque, so they completely cover the background.*

Low opacity – *the marks are light and transparent, so the background shows through.*

▲ **Opacity**
Digital brushes usually have an Opacity slider, which is a useful tool to master. Opacity controls how solid the colour you apply will be and how much it will cover up what is underneath.

BLENDING

In digital artwork, blending colours together is easy, and is a great way to make your paintings look smooth and slick. Blending colours is best done as you apply the paint. It is better to work carefully with low-opacity brushes, or brushes that smear colours together as you lay them down, than to use some of the more obvious Smudge or Blend tools. As with everything, think about where it is appropriate. For example, human skin benefits from gentle blending to give a smooth appearance, whereas an orc's skin looks far better coarse and textured with hard marks.

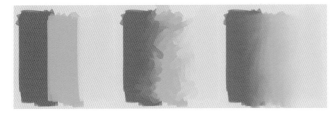

Unblended Coarse blending Smooth blending

▲ **Blending styles**
Here you can see three kinds of blending – experiment with how you can use different styles for different purposes.

LAYERS

Most digital painting software lets you add layers to your images. Layers are like transparent pieces of plastic laid over your work, which you can paint on without affecting what is underneath. Some artists use hundreds of layers in their work, so that they can tweak each tiny element. Some keep to just one layer, occasionally adding a new layer for an effect and then flattening it. More layers means a bigger file, so to handle lots of layers you need plenty of RAM (see page 12).

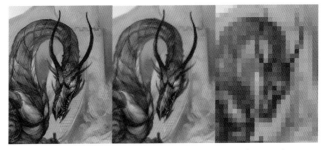

Layer 1 + Layer 2 + Layer 3 + Layer 4

▲ **Using layers**
In this illustration, each step is on a separate layer, so the background is separate to the line work, which is separate to each layer of tone and the highlights. Each can be worked on independently, and switched on and off.

IMAGE SIZE AND RESOLUTION

The size of your digital artwork and its 'resolution' can be quite confusing and abstract. Physical size describes the relative dimensions of the work (usually in inches) but when working digitally this isn't the end of the story. Those inches are divided up into a number of individual pixels. The more pixels per inch (ppi – often mistakenly called dpi – dots per inch) an image has the larger it is.

To print an image you really need to have 300ppi. To display well on screen you only need 100ppi. Think about what you want to do with your image. If you never want to print it out, then work at a low resolution to give your computer less work to do. If, however, you think you will want to print out your image at some point, then work at least at 300ppi at the desired physical size.

High resolution Medium resolution Very low resolution

▲ **Understanding resolution**
The three examples shown here reveal crucial differences in resolution. The high-resolution image would be suitable for printing, the medium resolution file will look OK on screen only, while the very low-resolution image will only work as a tiny thumbnail.

Planning

When creating fantasy art it is vital to plan your work, but this is an area that beginners often overlook. If you are thinking of putting in all the hours that a painting demands, half an hour of planning is time well spent and will really help your work to be the best it can be.

THUMBNAILS

A thumbnail sketch is a very fast drawing, containing almost no detail at all, but showing the layout of the elements within a painting. When making thumbnails, don't waste time making them pretty – they are just notes in sketch form to get you started. An alternative way to create thumbnails is to make quick models of environments, either with blocks or with modelling clay, and use a digital camera to photograph them from different angles that could be used for a painting.

◀ **Thumbnail sketches**
When making thumbnails you should work through as many different ideas for your painting as you possibly can. Sometimes you will find your first idea is the best. Sometimes it's the last of ten ideas that makes an image click.

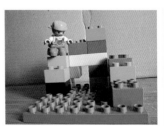

▲ **Models**
Try using children's building blocks to make an environment and place a character within it. Take photographs of it from different angles to see what would work best in a painting.

COMPOSITION

Composition means the arrangement of the things within your painting. The art of composition is a huge topic, but the important points are quite simple. Here are a few basic guidelines to follow:

- Don't put things in the middle – images with central elements are usually boring, so always try to move the important stuff off the centre line.
- Think in big shapes – how will the shapes in the image affect the viewer's eye? The eye gets pushed around a painting by lines and shapes, so you need to use this to your advantage. Corners of shapes and lines should point to the next thing of interest in the painting. Some of the best compositions are the simplest – V and X shapes are both very effective (see below and opposite).
- Keep the eye on the page – corners, in particular, are danger areas, so put something in each corner that brings the viewer back into the painting. Try not to have strong lines or patterns that point off the canvas.
- Direct the focus – think about where you want the viewer to look. Give the focal point of the image the highest contrast of light and dark, the finest detail and the highest level of colour contrast.

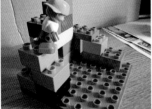

▲ **V-shaped composition**
This image is composed around a V shape. This is a good shape for action, as the brain thinks it will topple over, so it adds dynamism. A lot of comic book covers use Vs in their design.

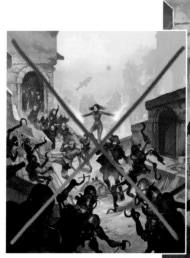

X-shaped composition ▶
This painting uses an X shape to lead the viewer's eye around the
image – different elements in the image work together to form two
strong lines crossing at the centre, bringing a sense of order to the
complex scene.

SKETCHING

Sketching is important before diving into painting, as it helps
you to plan your image and to familiarize yourself with it, so
you won't get any nasty surprises. Through sketching you will
find out what areas will challenge you and be ready for it. The
more you practise sketching, the more useful your sketches
will be. Sketches fill the gap between the initial idea shown
in the thumbnail (see opposite) and the final painting, which
would be an enormous leap to make unprepared.

REFERENCE

All good fantasy art has one foot in reality. You want your
settings, characters and creatures to have a certain level of
realism to 'win over' the viewer. A good way to do this is to
collect reference from books, magazines and the Internet.
Reference images help you get the details right be they a
Roman helmet, the puckered skin on the arm of a beast, the
moss on some rocks or the craters on the moon. Sometimes
it's tempting to try and make everything up, but drawing
from reference is far smarter. It isn't about copying or being
unoriginal – it's about taking inspiration from the real world
and getting things right.

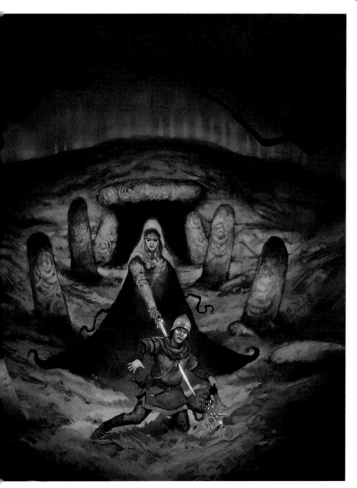

◀ Focal point
In this image, the strongest contrast and the lightest part of the
image is the ghost's face which makes it stand out from the other
colours and draws the viewer's eye to it.

Colour

Using colour can be one of the most daunting aspects of making fantasy art. Colour theory is a complicated topic and for a beginner a lot of the information is just too full of jargon to digest. Here you will find the very basics to help you understand colour and the effect it has on your images.

THE COLOUR WHEEL

The colour wheel is a handy chart that shows the colours of the spectrum and how they relate to one another. Each colour mixes into the next. Colours opposite each other on the colour wheel are very strongly contrasting and are called 'complementary' colours. When these colours are put next to each other they really intensify. This can be a great tool when making a painting with elements that stand out.

▲ **Colour wheel**
The colour wheel shows how the spectrum or rainbow of pure colours meets at one end to form a circle.

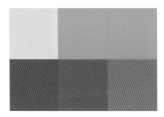

◄ **Complementary colours**
Complementary colours in their pairs – purple and yellow, red and green, orange and blue. These colours intensify each other when placed together.

CHOOSING COLOURS

When painting it is a good idea to 'limit your palette'. This means you don't use all the colours there are in one painting, but carefully choose a few and only use different versions

of those colours. A good tip is to pick three colours next to each other on the colour wheel. That way all your colours relate to each other, and you will create what is called a 'harmonious palette'. For more contrast, pick two neighbouring colours from the colour wheel and one from the opposite side for contrast.

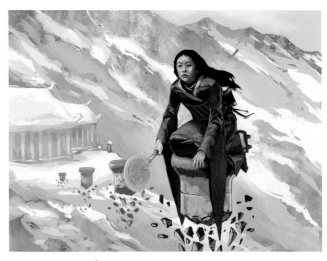

▲ **Contrasting palette**
In this image, the pale blue background contrasts strongly with the strong orange of the character's clothing, 'popping' her out of the scene.

THE QUALITIES OF COLOUR

To talk about colours, we first need to understand the different qualities of a colour that make it what it is. Colours have three aspects to be aware of:

HUE

Hue is what you might most easily think of as colour – it is green, red, orange and so on. On the colour wheel, hue changes around the rim like the numbers on a clock.

VALUE

Essentially, value is art jargon for light or dark. A colour with a high value is light; a colour with a low value is dark.

SATURATION

Saturation describes how strong a colour is. A low-saturation colour has a more grey appearance, a high-saturation colour is more pure.

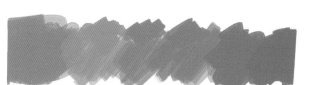

Saturation – *high-saturation colour on the left fades to low saturation on the right.*

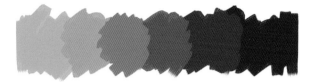

Value – *the saturation remains the same but the value decreases from left to right.*

Hue – *here you can see the range of pure hues – the rainbow or colour spectrum.*

COLOUR TEMPERATURE

The colours on the colour wheel are split in two kinds – warm and cool. Reds, oranges and yellows are warm colours. Greens, turquoises and blues are cool colours. It is worth knowing that warm colours come forwards ('advance') in a painting and cool colours move backwards ('recede'). If you put something very warm in the far distance of a painting it will leap forwards. Colour temperature is relative though – what is thought of as a warm colour can look cool when all the other colours around it are much warmer, and vice versa.

Warm colours (those in the range of yellow to red) advance in an image.

The colours in the spectrum from green to blue are cool colours, which recede in a painting.

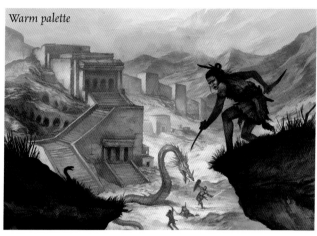

Warm palette

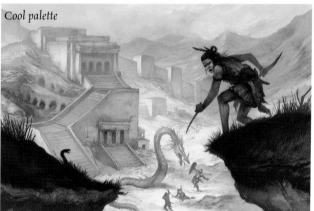

Cool palette

▲ Warm and cool

The effect of colour temperature is clearly visible when you look at the same image painted first with a warm palette and then with a cool palette. Look how frosty the same image looks when it has cold colours, and how dry and hot it looks with warm colours. Your colour choices will set the mood of your paintings.

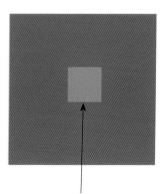

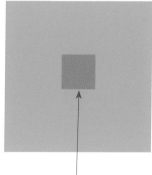

The red background makes the grey square look green.

The green background makes the grey square look red.

▲ Relativity

Colours look different depending what they are placed near. This example shows the same grey squares on two different backgrounds. Notice how the grey square looks a different colour in each one. This is the amazing power of colours.

Lighting

Lighting in fantasy art is extremely important. The magical qualities of fantasy paintings are created and enhanced by good use of light. Lighting is one of the most challenging aspects of making artwork but fortunately, with some effort, it can be understood and, with practice, it can be successfully put to work in your paintings.

LIGHT SOURCES

All light comes from 'light sources'. These can be real-world sources such as the sun, a light bulb or a neon strip, but they could also be magical, like the fiery breath of a dragon, the glowing orb held by a wizard or the mystic aura of a standing stone. Sometimes light sources will feature directly in paintings and sometimes only their effects will be shown.

The first rule to learn is that light travels in straight lines. When light hits a simple object, which parts of the object will be in full light, which parts will be less bright, and which parts will be in full shadow?

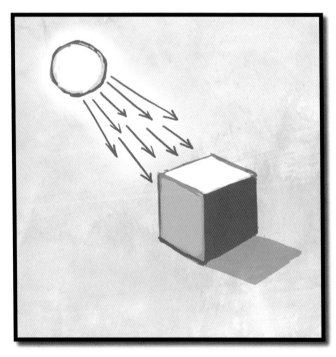

▲ **Simple lighting**
Here you can see the light source sends out rays of light straight on to the top of the cube. A little light seems to hit one side, and none hits the back of the cube. The cube also blocks some of the light from hitting the ground and so a shadow is formed.

SECONDARY LIGHT SOURCES

But light is not that simple – it also bounces. When lighting a shape such as a ball, some of the light that is hitting the ground around the ball bounces back up, lighting up the shadow side slightly. Shadows are often not just flat darkness. Because some of the strongest light is being blocked, it allows lesser, 'secondary' light sources to show up, of which bounced or 'reflected' light is one. Secondary light sources are usually not as bright as the main light source but where that main light source casts a shadow then the lesser light source can have an effect. A common technique is to have the main light source coming from one direction, and a secondary source coming from the opposite direction.

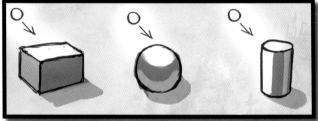

▲ **Lighting shapes**
This diagram shows how three basic shapes look in simple lighting conditions. On the ball and the cylinder, the area that is not in shadow and not in full light can be quite hard to place. On the ball, light bounces and lights up the underside very slightly.

THE COLOUR OF LIGHT

The second rule of lighting is that all light has a colour. It is very rare to see pure white light. Light bulbs have a very yellowy light. The sun is slightly yellowy. A lot of the light outside has a blue tinge because it has come through the blue sky. The colour of a light source is referred to as its 'cast'. If you can remember that all light has a cast of some kind it will help you choose colours and make realistic lighting schemes.

THE COLOUR OF DARKNESS

The third simple rule is that shadows have colour too – they are not just black or grey. In fact, they have the opposite or 'complementary' colour (see page 24) to the light that cast them. A yellow light will give shadows with a slight purplish tinge. An orangey light will give bluey shadows. Reddish light makes greeny shadows. To know what colour your shadows should be, you need to know what colour your light source is.

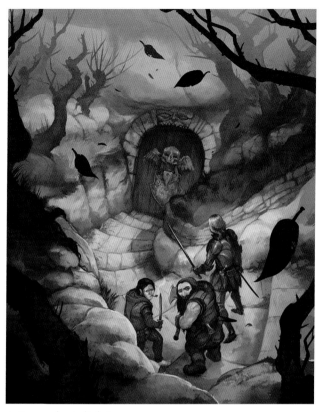

▲ Atmospheric lighting
In a misty or smoky scene, light gets bounced around and there are less direct highlights and shadows. In this painting, the lighting is restrained and a greyish greeny light makes something feel not quite right. If the light were a sunny yellow, the mood would be very different and not appropriate for what is happening in this image.

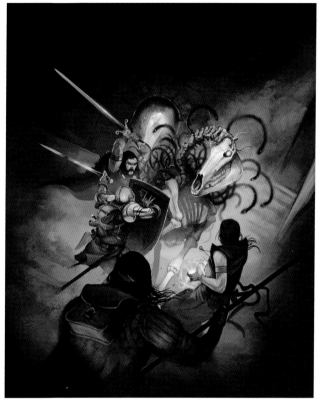

▲ Weird light
In fantasy art, there are endless possibilities for creative lighting, from magical spells to the fiery eyes of a serpent. Here, the green crystal informs the lighting and lots of deep shadow frames the scene. The action is illuminated from the top right by a shaft of light. The magical effect in the wizard's hand is a secondary light source.

SHADOWS

In fantasy worlds, shadows are powerful tools. Make them really huge and dramatic. Shadows can help define the shape of objects. In fantasy art, we often draw strange or unfamiliar objects so a cast shadow gives another, more simplified view of it in silhouette, which will help the viewer to make sense of what they are seeing. Shadows can also be a positive element for your compositions. Use big shadows for drama, but also to carve up the space of the canvas. You can frame the important parts of the painting or drawing with shadows. Be smart and control where they fall and what size they are.

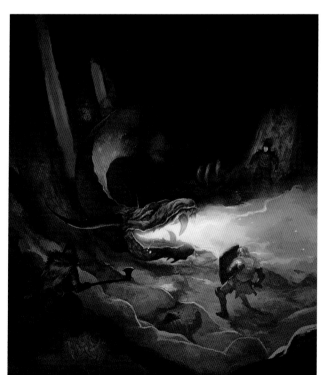

◄ Light and shadow
In this painting you can see how the yellow/orange fire is lighting everything up. All the shadow areas are shades of blue and purple, which are the complementary colours to the fire.

LIGHTING AT WORK

Lighting can be as simple or as complex as you want it to be. A line drawing may not address lighting much at all, but a fully rendered watercolour painting can be lit to such a degree that it almost appears to be reality. Lighting is something worth considering from the early stages of a piece and can become a key feature of the story you are trying to tell. It can add drama and mood, either subtly or graphically.

To really explore the effect of various kinds of lighting, take a look at Cedric the wizard shown here in a selection of different lighting conditions. Hopefully, this will give you some ideas for your own paintings, and by being able to compare the same character in different lighting situations you can get some ideas on how they are achieved. Notice the dramatically different moods created in each image.

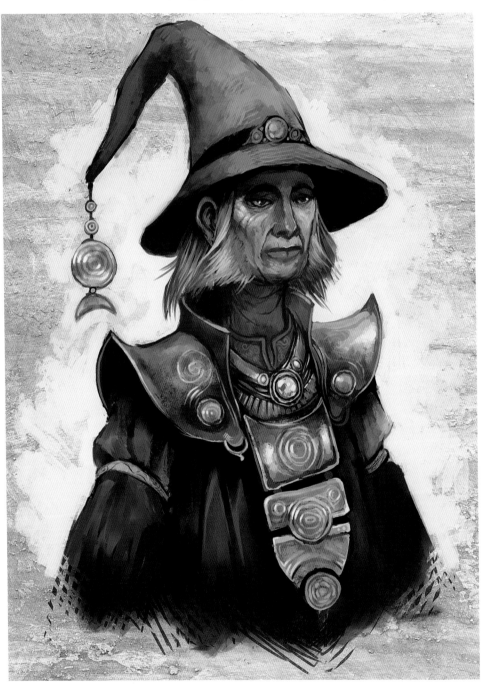

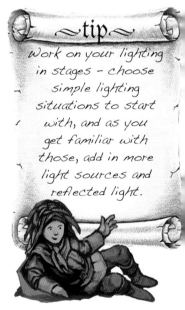

~tip~
Work on your lighting in stages – choose simple lighting situations to start with, and as you get familiar with those, add in more light sources and reflected light.

▲ **Ambient lighting**
Standard, neutral lighting is called 'ambient' lighting. Cedric is equally lit from all sides here – there is no clearly defined light source and his clothes all retain their natural or 'local' colours. Ambient lighting shows us the character clearly, but it isn't very dramatic.

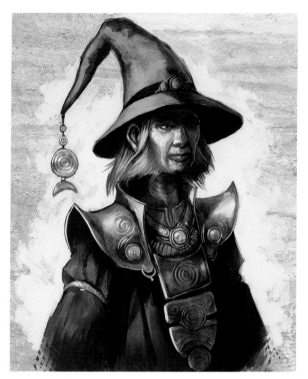

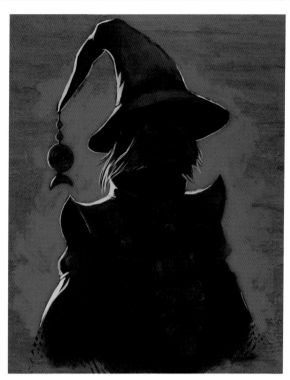

▲ **Side lighting**
When Cedric is lit from one side, shadows are cast across the side of his face and hat, while the edge of his golden breastplate is brightly lit up. This all helps emphasize the shapes that make him up and is much more dramatic than ambient lighting.

▲ **Back lighting**
Lit from behind, most of Cedric is in deep shadow. The thin slivers of pale moonlight are called 'rim lights' or 'edge lights'. Using this technique enables you to make the most of a dramatic silhouette, as well as adding mystery and drama.

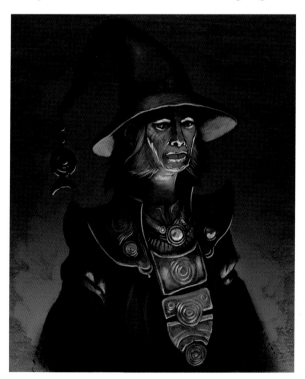

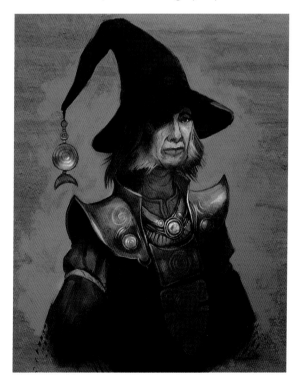

▲ **Up lighting**
The overall lighting here is green but there is a yellowy light illuminating the underside of Cedric's face, creating an eerie effect. Use a torch and a camera to take some reference photographs so you can observe how and where the light hits.

▲ **Spotlighting**
This dramatic technique allows you to highlight the focal point of an image using both strong light and dark shadow on one character or object. A quick way to achieve this effect is by overlaying a series of washes where the shadows fall.

Imagination and Development

Once you have made some progress on your journey some new questions may begin to arise. How do I get new ideas? How do I imagine things? How do I stay enthusiastic? Am I getting any better? These questions are normal and healthy, and this section will show you how to answer them.

WORK YOUR IMAGINATION

Imagination and creativity are just like muscles – they get tired, but they do grow stronger with work. A routine that includes plenty of exercise for your imagination is good. Set aside a part of every week to come up with ideas. When travelling on the bus to school or work, or when watching a boring TV show, have a notebook nearby and record ideas for paintings – situations to illustrate, subjects to try, concepts to include – and build up a rich source of ideas. Then try out some thumbnails in your sketchbook. The more ideas you note down, the more you will get.

REST YOUR IMAGINATION

It is tempting to push yourself to think up ideas all the time. Ambition and drive are good things, but give yourself a break. Sometimes you will run out of mental energy, but don't panic, just take a rest from fantasy art, do something else and your powers will return. The most inspiring things can be right outside your door, so collect some new experiences away from the sketchbook. If you are keen to do something creative but have exhausted your brain, try going for a walk with a camera. Photography can provide great reference and relaxation.

FEED YOUR IMAGINATION

Your imagination also needs food to work properly. You cannot work in a vacuum. Immersing yourself in other people's creativity can be a great way to feed your own imagination. Films, books, TV, other artist's work, and just chatting with friends about their various creative projects can all feed your brain.

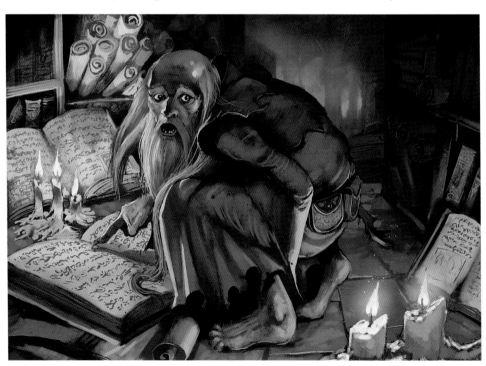

◀ **The Scholar**
A wizard driven insane by the weight of things he has yet to learn! A strong light source gives this image suitable drama.

Developing as an artist

Here are a few things you can do in order to develop and improve:

- Work on your artwork regularly – perhaps dedicate one night a week to it or however much time you think you can set aside without distractions.
- Mix up the kinds of work you produce to keep things fresh – sometimes do speed sketches in your sketchbook, sometimes concentrate on finishing one piece of painting, sometimes work on improving your figure drawing.
- Set yourself achievable goals – almost all fantasy artists at some time have decided to draw or paint a 50-page comic book and failed. Instead, think about illustrating a three-page comic-book story, which could be done in a month or two. Don't set your goals way out of reach, as it will only demotivate you.
- Join an Internet community – not only to show your work but also to chat to other artists. Be very careful when joining any online community not to reveal any personal information and follow all the guidelines for staying safe.
- Take a night class and mix with other aspiring artists – sharing your experiences is very healthy, and it is always heartening to hear other people's stories.

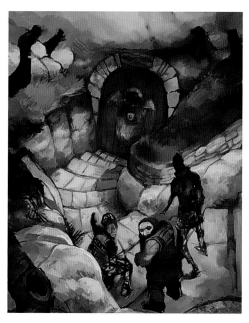

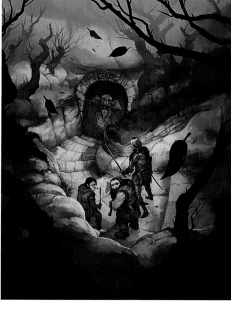

ASSESSING YOUR PROGRESS

Persevering with your drawing and painting, even when the going gets hard, is the true mark of dedication. It takes a certain amount of faith to believe that you are improving sometimes. But it is worth keeping the faith because the alternative is to give up on the journey, turn around and head home and that would be a real shame.

To help with this, make sure you keep a sketchbook and date the pages as you fill them. Date all your work, and file it away somewhere safe. Keep a journal about how you feel your art is going. Every couple of months or so, take a look back over your older work, your journal and your sketchbook. Notice how much you have improved and be sure to give yourself a pat on the back.

◀ **Image development**
An image develops from a doodled location idea, into a loose sketch, to a painting in progress, to the final article.

~ Part 2 ~

This part of the book reveals how to create six fantasy archetypes step by step. Each demo starts with sketchbook ideas, moves through drafting the basic shapes to the finished drawing and then into paint through washes to adding details and highlights. You can follow the steps as far as you want – ending at the initial sketch, the final drawing, the wash or continuing through to the finished painting.

Barbarian

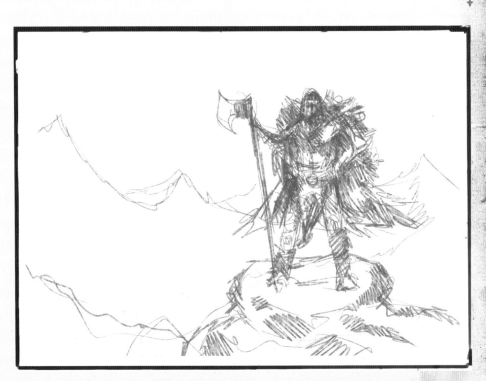

Striding from the pages of a thousand fantasy novels, barbarians are muscle-bound, loincloth-wearing, axe-wielding warriors from wild, untamed regions. To keep it simple, this image will focus on the character by placing him in a very minimal setting. In the painting stage, earthy colours will be used to help convey his base and savage nature.

PREPARATORY WORK

The only way to start any illustration is to get out the sketchbook and do lots of quick-fire sketches. These do not need to be at all polished or finished – they are just for you to help get your imagination working. Try out different ideas for poses, hairstyles, weapons – whatever elements you think you might want to feature in your final image. Working through your ideas in this way will help you

come to informed decisions, rather than launching into constructing a full-blown image without having first worked out what you want to include.

When you have a clearer idea of what you want to draw, do a quick 'thumbnail' sketch to plot out the basic elements. This should be very rough – don't spend hours on it; just establish the core components in a fast, scribbly drawing.

Thumbnail sketch ▶
When your ideas are clearer, do a very rough thumbnail sketch to put down the basic concept for the final image. In this case, this is a single figure standing in a wide landscape. Think about the composition and where best to place the main elements for maximum effect (see pages 22–23).

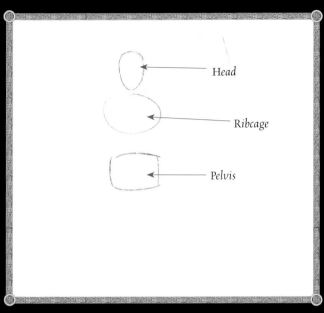

Head

Ribcage

Pelvis

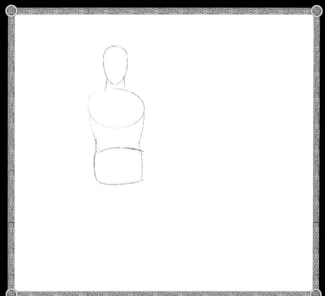

1 Take an HB pencil and draw a rough egg shape for the head. Make sure you position this carefully on the page, ensuring there is enough room for the rest of the figure. Add an oval underneath the head for the ribcage then a little way below it, draw a box for the pelvis.

2 Draw two lines to join the pelvis and the ribcage shapes, forming a basic torso. Draw another two lines for the neck.

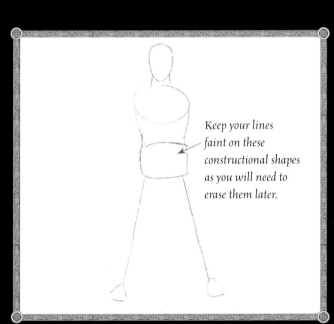

Keep your lines faint on these constructional shapes as you will need to erase them later.

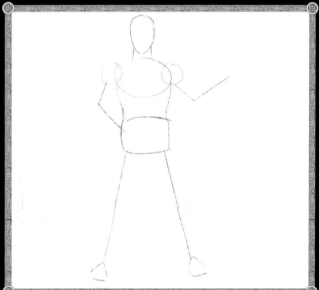

3 Draw two straight lines for the legs in a fairly wide stance. The waist comes about halfway down the figure, which gives you a useful guide for the proportions of the legs. Add two triangular shapes for the feet.

4 Mark two circles to show the position of the shoulders. Draw in simple lines for the arms with his right arm resting on his hip for a commanding stance and his left arm bent to hold his axe.

5 Begin to flesh out the legs using oval shapes for his chunky thighs and small circles for the knees.

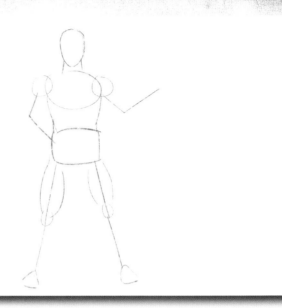

6 Continue down the legs, adding ovals for the calves and shins. Follow the construction lines and draw each limb as carefully and correctly as you can – you can use a reference photo to help you if necessary.

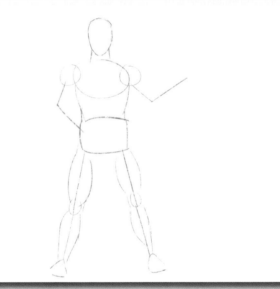

7 Flesh out the arms in the same way as the legs, using rounded ovals for the upper arms and longer, thinner ovals for the forearms. Add two box shapes for the hands. Draw in a cross on the head to show the direction of the face and to help position the facial features later.

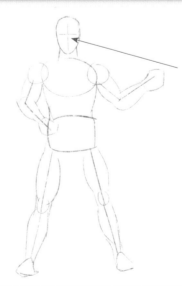

Draw the cross absolutely central on the face to show that he is looking straight ahead.

8 Join everything up with a simple smooth outline to make the figure look more human-shaped – again a reference photo may be useful here.

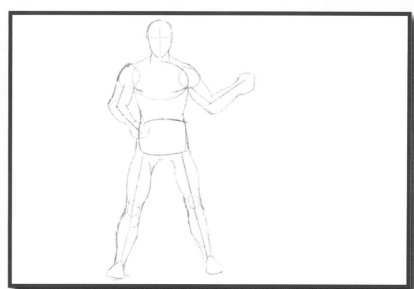

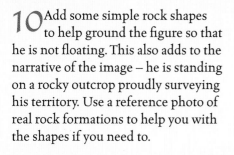

9 Draw in his axe handle with two closely spaced parallel lines going from his hand down to his foot. Draw the axe blade on top with the curve of the blade facing outwards.

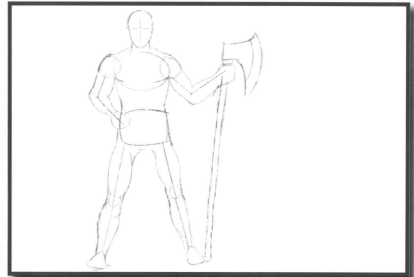

10 Add some simple rock shapes to help ground the figure so that he is not floating. This also adds to the narrative of the image – he is standing on a rocky outcrop proudly surveying his territory. Use a reference photo of real rock formations to help you with the shapes if you need to.

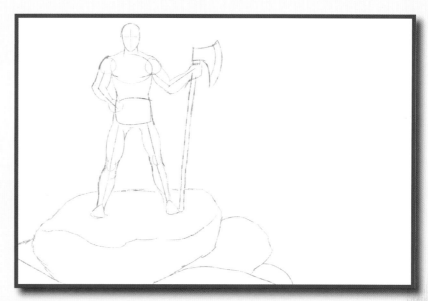

11 Block in the shape of his hair. Draw quite a sharp straight line across his forehead to show the squareness of the haircut and then add the basic shape of the long hair at either side of the face.

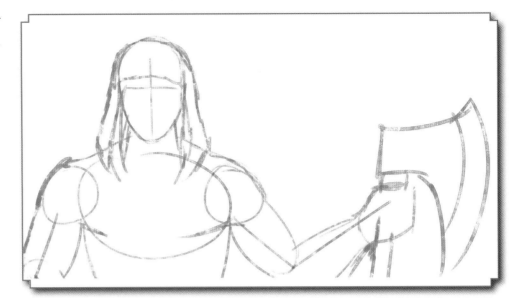

12 Add the fur cloak by drawing a very jagged, rough-textured line going all around the edge of the figure. Draw the shape billowing out to the left of the image to show some movement and also to help balance the composition. Draw the loincloth hanging down between his legs in a rough triangle shape.

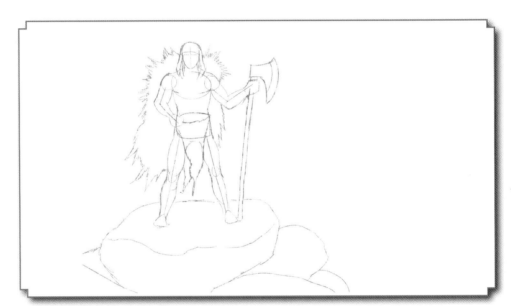

13 Spend a few moments erasing the construction lines that are no longer needed to help keep the drawing clear.

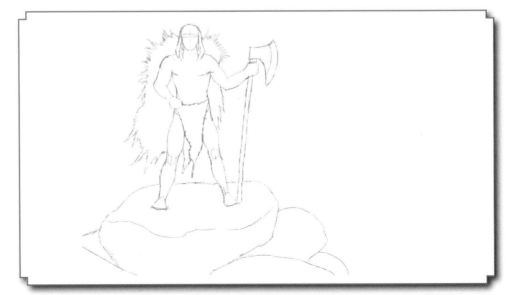

14 Draw in his facial features. Draw
the eyes on the horizontal line
of the construction cross. Draw in a
wide nose on the vertical centre line
with the mouth just below it. Add
some lines on the cheeks to suggest
chiseled cheekbones. Then carefully
erase around the features to remove
the guides.

*When drawing the eyes, the space between
them should be roughly the size of one eye.*

15 Add a chunky barbarian-style belt
to the figure. Add the outline of his
fur boots with soft, jagged lines, closely
following the shape of the lower legs.

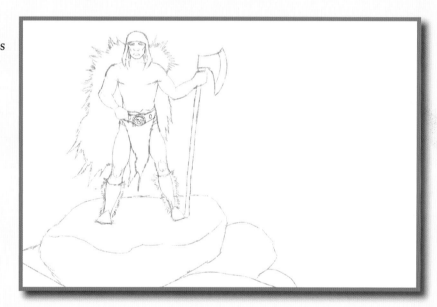

16 Add lots of jagged lines across
the boots to suggest that they are
made up of strips of fur wrapped around
his legs.

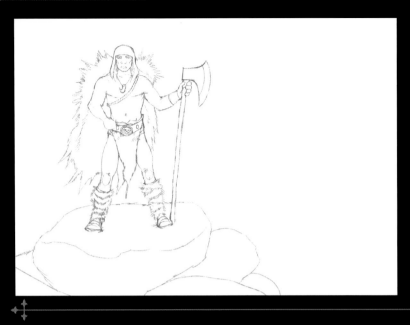

17 Add some accessories – a tooth necklace, an armband and a strap going diagonally across his body. Add some detail into the fur cape with a few extra jagged lines. Go over any important lines more confidently and firmly with your pencil to refine them.

18 Add the final accessories and details like earrings, stray wisps of hair and little details on his equipment like etching on his axe and designs on his jewellery. Clean up any stray lines with an eraser then take your pencil around the image and emphasize where any lines overlap by pressing more firmly.

Add slightly heavier lines around any important parts of the image so it is very clear for painting.

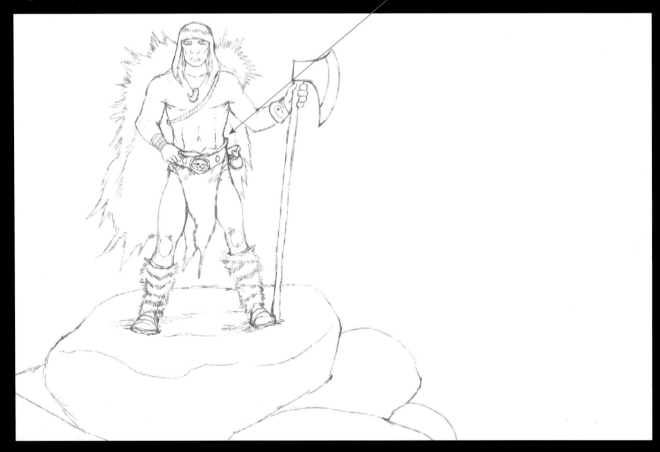

19 The aim now is to cover the white paper and give a base colour scheme to work with. Lay on some loose, messy washes with large brushes. Don't worry about destroying the pencil image – this is now just a guide for painting – but if you want to keep it (either to refer to later or just for posterity), scan or photocopy it before adding the first wash.

Use a very clear blue for the sky, and a reddy orange for the rocks and the barbarian so that they stand out against the background.

20 Following your pencil guidelines underneath the initial wash, use a grey-brown wash and a medium brush to fill in the figure, including his axe and cloak.

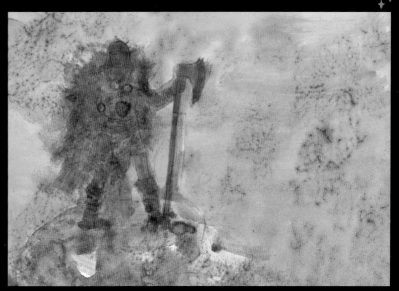

21 With some thin flesh-coloured paint and the same medium brush, carefully fill in all the areas where skin is showing. Thinning down the opaque paint allows the drawing underneath to show through so you can follow the drawn guidelines more easily.

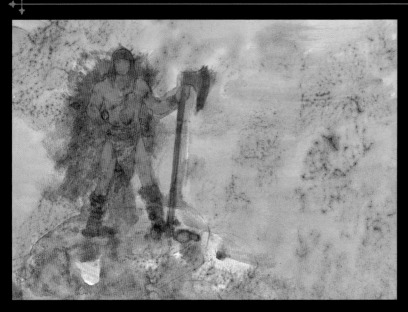

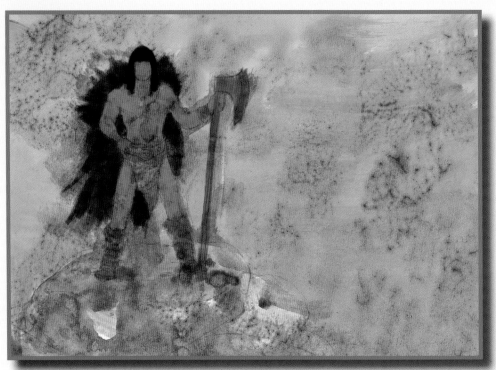

22 With the same medium brush, use a dark-brown wash to put some deeper tones into his cloak then use a blue-black wash to paint in the basic shape of his hair.

23 Wash in his axe handle, axe head, fur boots and loincloth with a mixture of greys and browns. This slow build-up of washes helps you to create attractive looking paintwork in small, achievable steps and allows you to describe what you are painting little by little, which is much easier than trying to paint the finished article in one giant leap!

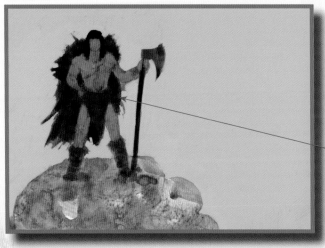

24 Take some opaque sky blue and paint in all around the figure. Use this opaque paint to literally 'carve out' the outline of the cloak and the axe. While it is a shame to lose the textured wash in the sky, the detail was drawing the eye away from the figure. Making it flat and smooth works much better for this image.

Rather than painting the figure on top of the background, use the background colour and a small brush to paint right up to the edge of the figure, so you can control the edges very precisely.

25 With a lighter flesh colour, paint in some highlights on the skin in areas where the light is hitting them directly, such as the thighs and chest. In this image the lighting is ambient (see page 28) without a strong single direction, but because the sun is in the sky the light falls principally from above.

Any surfaces that are tilted slightly upwards will be hit by the light and so should be painted with highlights.

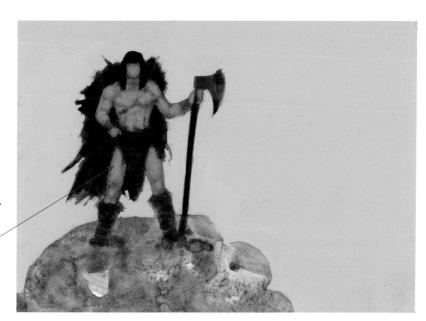

26 With an even lighter flesh colour, repeat the previous step but slightly more selectively inside the shapes you just painted so that a highlighted area starts to build up. With each stage, get more detailed in what you are doing by being a little more careful with how you apply the paint.

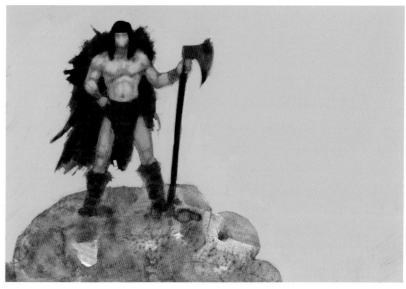

27 Lay in a browny wash to establish the basic shapes of the rocks. You can look at photographs of rock formations to guide you in this. These rocks are weathered and rounded so work with big irregular ovals.

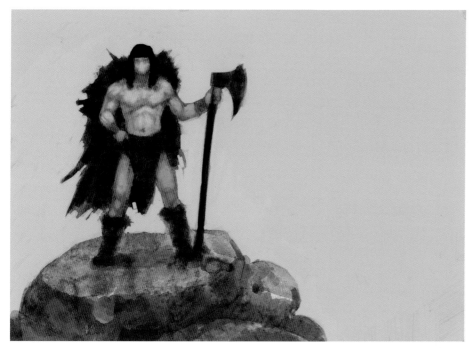

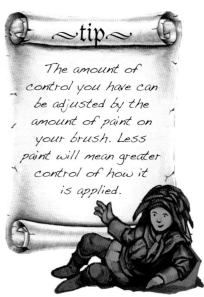

~tip~

The amount of control you have can be adjusted by the amount of paint on your brush. Less paint will mean greater control of how it is applied.

28 Use the same process on the rocks as you did on the flesh, building up layers of thin opaque paint, getting lighter and lighter with each pass. Form the flat, table-like qualities of the rocks by leaving whole areas untouched to show the vertical sides that are not being struck by the sun.

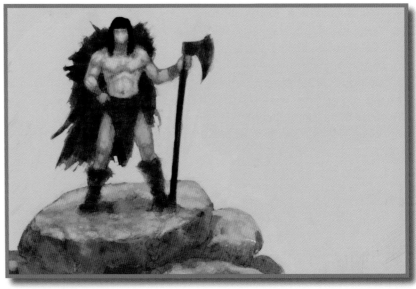

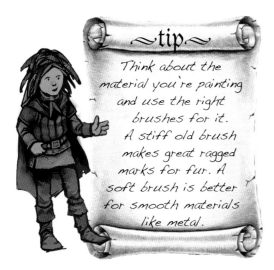

~tip~

Think about the material you're painting and use the right brushes for it. A stiff old brush makes great ragged marks for fur. A soft brush is better for smooth materials like metal.

29 Using some opaque brown and a very fine brush, carefully paint in some parallel lines on the shaft of the axe to show the wood grain. For the axe head, start with a base of opaque greys and browns then add highlights with lighter shades of the same colours. Use a bit of sky colour to sharpen up the edges and nick in a chip in the blade.

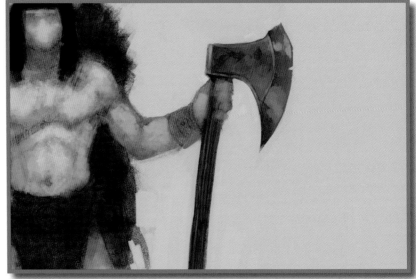

30 Move on to his belt and loincloth, scrubbing on some little marks to show the texture and highlights. Load some paint on to a medium brush and wipe most of it off on a piece of scrap paper or a rag. Carefully scrub what little paint is left on the brush on to these areas. Use the same brown colour with white and a little yellow mixed in for the highlights.

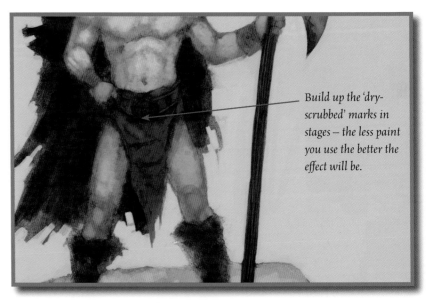

Build up the 'dry-scrubbed' marks in stages – the less paint you use the better the effect will be.

31 Continue working on the loincloth adding highlights. Think about where the light will fall and where wrinkles in the material will be placed. Any time you can spend drawing cloth and leather from real life is time well spent. Being able to make these aspects look realistic will really improve your image.

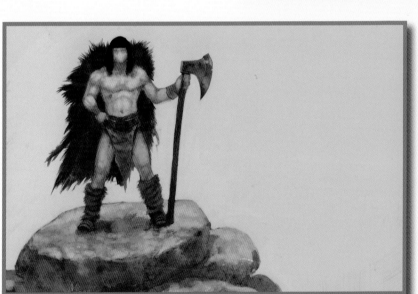

32 With a variety of browns and blacks, flick little marks all around the outline of the cloak to make it jagged like rough fur using both a fine brush and a ragged old brush. Overlay another round of these marks in the same colour to really add depth to the fur. Repeat the process on his furry boots – adding midtones and highlights then using the opaque background colours to carve out the shapes.

33 Now paint the face. Sometimes the painting process will cover up the sketch underneath so you may need to plot out his features again at this point. If you kept a copy of your sketch it will be useful now. Try to make him look as masculine as possible with a square chin, wide nose, craggy face and strong brow.

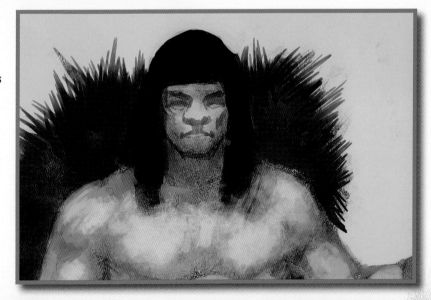

34 Apply some highlights to his face across the cheeks, the brow, the nose and the top lip. Add some flecks of highlighting to his chin to make it even craggier. With a small amount of very dark brown just touch in the eyes. If this were a female character you could emphasize the eyes far more, but for a man you need to play them right down.

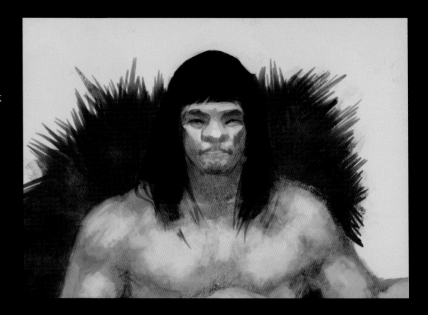

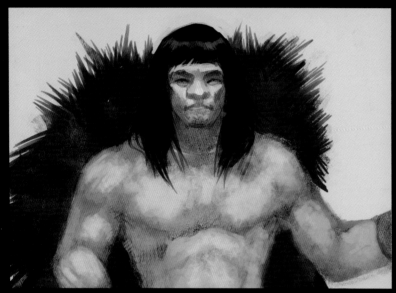

35 Add some strands of hair with a very fine brush using the blue-black colour. Paint in a ring of highlights on the top of his head using the sky colour, as shiny black hair is so reflective that the colour of the sky can be seen in its surface.

36 Add flesh-coloured highlights where the sun is striking his body, particularly on the chest and thighs. Then take a step back and look at what needs work. His cloak looks a bit lopsided, so add in more cloak on the right-hand side to even it up then turn your attention to your edges, neatening them up all over the piece with a fine brush.

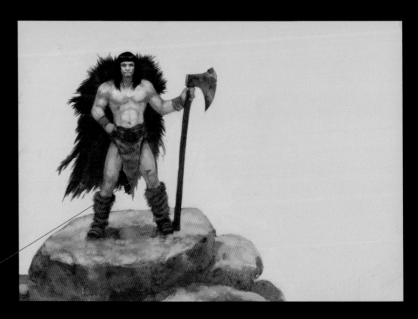

Make sure that the edges of the figure are smooth like flesh. For example, where the edge of his leg meets the background paint a smooth line.

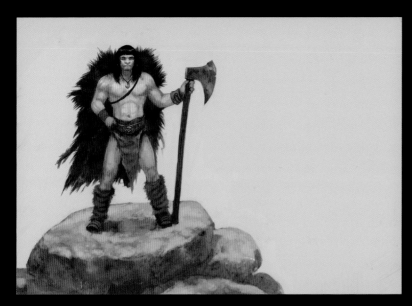

37 Add his accessories – the rope across his chest to hold his fur in place, a couple of different armbands, a necklace and some earrings. Use a fine brush and begin with a browny base colour then do a couple of passes with lighter colours – yellow for the gold and lighter browns, and whites for the tusk around his neck.

38 Add more contrast and direct shadows using a browny wash underneath any area that would be casting a shadow. Paint in finer shadow areas under his accessories to make them look more solid. Paint in the hands, looking at your sketch or a reference photo to guide you. Neaten up any messy shapes and add one or two very crisp highlights on his gold jewellery and face, which will draw the eye to those areas, and your barbarian is finished!

~tip~

Always take a few days' break from your paintings and come back to them with fresh eyes. You may decide that you have added enough detail, or may see areas that could be improved.

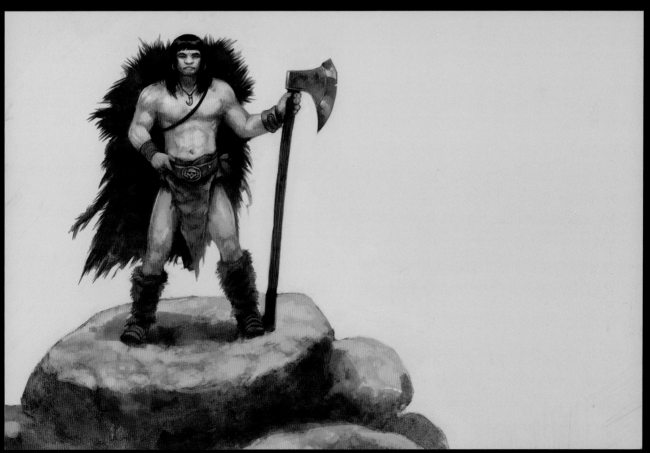

Barbarian

Danak the Barbarian King

This image shows what can be done with lots of patience, practice and continuation of the simple techniques shown so far. There is nothing extra in this more polished image beyond practice. By investing some more time in applying further washes and highlights, in exactly the same way as in the step-by-step stages, you can really enhance your image. Details like clouds and washed-on tattoos add an extra dimension and help bring the painting to life.

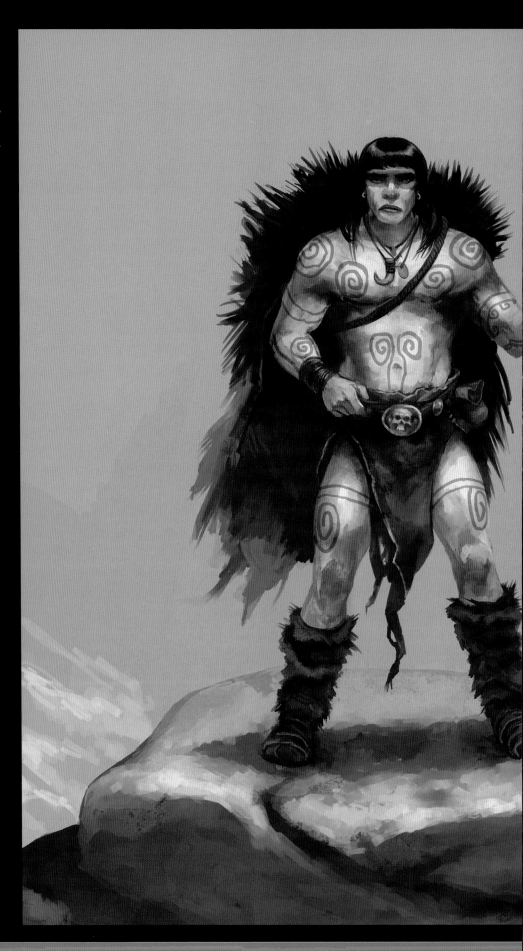

Wizard

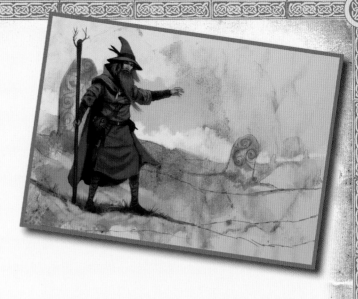

In fantasy stories wizards are guides and mentors. There are many different sorts but this demonstration tackles a familiar grey wizard with a pointed hat, staff and beard. The image has a mystical atmosphere and uses a fresh palette of greens and greys. The techniques involve painting simple fabric in his costume and getting life into a figure.

PREPARATORY WORK

Open your sketchbook and do lots of initial sketches. Sketching is an extremely useful exercise to get your brain working, and to get as many ideas about poses and designs as you can. With practice, you can get a lot down very quickly and really open your creative floodgates.

When sketching, try out as many different takes on the subject as you can think of. Just go wild and try not to limit or censor yourself. A wizard can have a wide variety of poses and aspects to his character, so be sure not to miss any good ideas by rushing this stage.

Try a dynamic pose with arms raised as if casting a spell.

A book as a prop shows his scholarly nature.

A well-travelled wizard in weather-stained clothes.

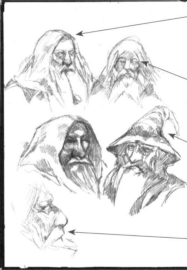

Perhaps he could be a pipe smoker.

Baggy eyes show his age and wisdom.

Try variations in headgear – a hood and a classic wizard's hat.

Sketch out the face in profile too.

Thumbnail sketch ▶
Through sketching out ideas, eventually you can settle on a design to take further. This one is simple but has all the classic elements – the hat, the cape, the magical accoutrements in various pouches and, of course, the wizard's staff – without being too ambitious.

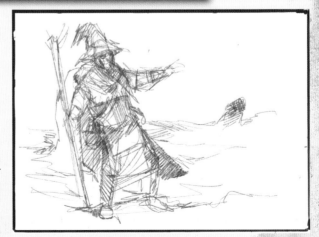

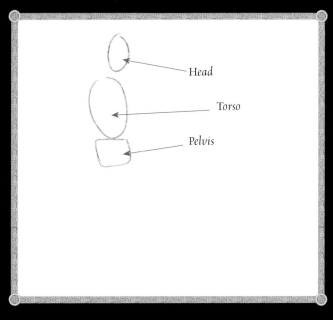

Head

Torso

Pelvis

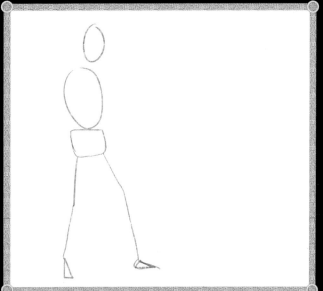

1 With an HB pencil, draw an egg shape for the head. Make sure you place it so that the rest of the body will fit on the page. Beneath it, draw a rounded oval tilted slightly backwards for the torso to show the wizard is leaning. Underneath this draw a box for the pelvis.

2 Draw in two lines for simple legs. Bending the knees makes the character look a little more dynamic, as if he is in motion or about to move. Add two roughly triangular shapes for the feet, pointing his right foot towards the viewer and his left foot outwards.

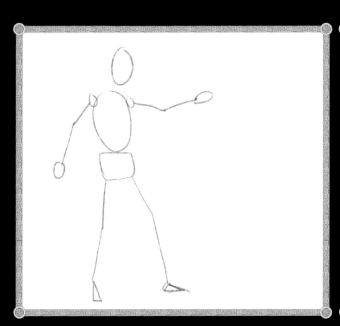

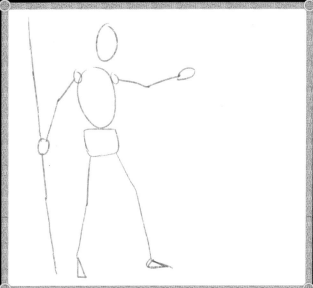

3 Add two small circles to the top of the torso for the shoulders then draw in simple lines for the arms. His right arm is down at his side and his left arm held out away from the body. Draw a rounded shape on the end of each arm to indicate the hands.

4 Draw a line slightly longer than the height of the figure to represent his staff being held in his right hand. This is such an important accessory for a wizard that it is important to get it in place from the start.

Wizard

5 Draw a cross on the head to show the direction of the face and the position of the major facial features, which will be added later. The vertical line is where the nose will sit and is placed according to the direction the head is turned in. Here, the wizard is facing outwards, so the line is drawn to one side. Curve the lines to show the three-dimensional shape of the head.

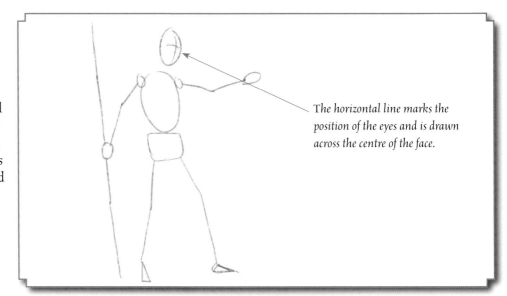

The horizontal line marks the position of the eyes and is drawn across the centre of the face.

6 Carefully and slowly add an outline to the figure, following the construction lines and drawing each limb as correctly as you can. Using reference photos can help with this. Add some bulk to the staff too. Mark a line down the centre of the chest so that you can keep track of the centre line of the figure and indicate the direction the torso is facing in.

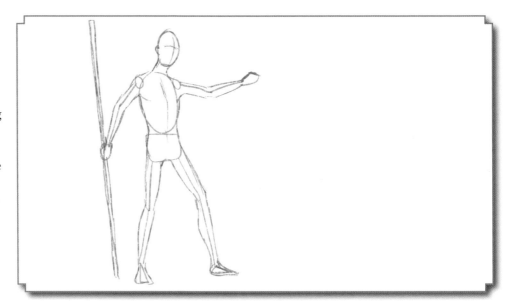

7 Erase the majority of the construction lines, making sure you leave the cross on the face to help draw the features later and the line in the centre of the chest.

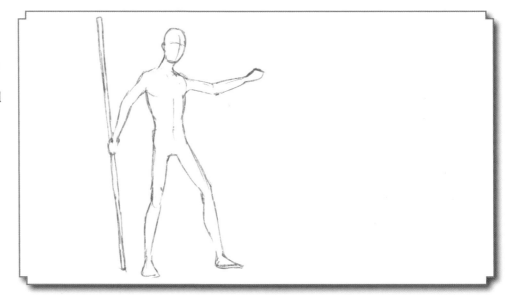

8 Start to add some clothing. The aim is to give the wizard a lot of layers to add interest to his costume, so start off with a long tunic. Draw in the skirt following the line of his legs and cut out a small inverted 'V' shape next to his right knee. Add a top with short sleeves, joining the skirt at the waist.

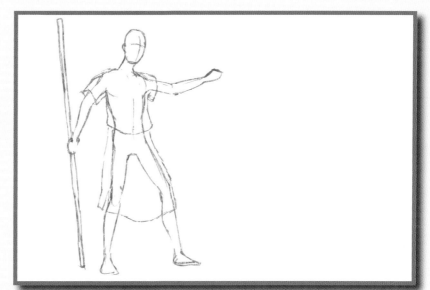

9 Next draw in some longer sleeves and a shorter tunic overlaying the long skirt. Try to think about the shapes of the limbs that the fabric is lying over and make the bottom edge curved to show form. Then add the outer brim of the hat by drawing an oval shape around his head.

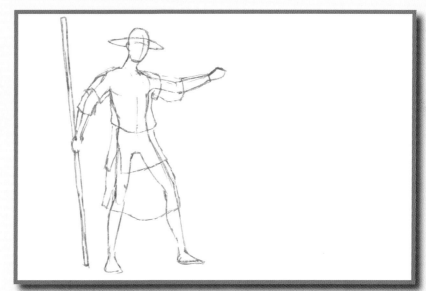

10 Add the outline of the rest of the hat, drawing an almost shark-fin shape on top on the brim. It will look slightly too big around his head, but remember that his hair isn't in place yet. Then erase the unnecessary construction lines to keep everything clear.

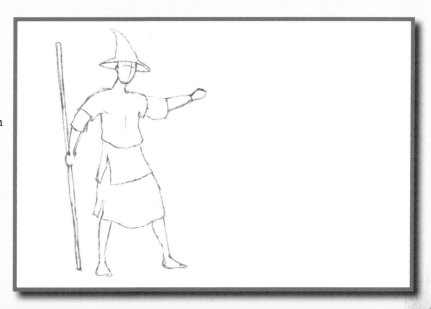

11 Add his cloak. To give the figure a little movement make sure the fabric flares outwards, forming a triangular shape. This also gives the cloak some volume. Notice how the fabric piles up on his shoulders – this detail is observed from life and really helps make him look grander.

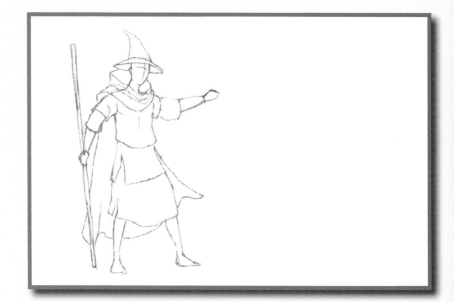

12 Take the eraser around the drawing again to remove any unnecessary construction lines after adding the cloak. Go over any important lines more firmly with your pencil to refine them and keep things neat and clear.

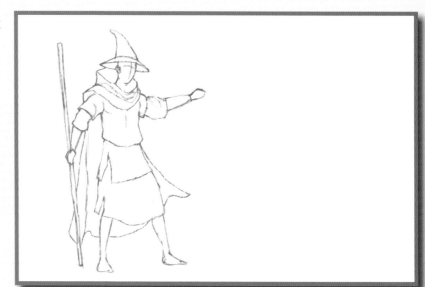

13 Draw in his facial features, placing the eyes on the horizontal line of the cross and with roughly one eye's space between them. Draw the nose on the vertical line with the mouth just below it. Add an ear, the top of which is level with his eyes, and the bottom roughly level with his mouth. Add some lines on the cheeks to give him a wrinkled, wizened look. Then carefully erase around the features to remove the construction cross.

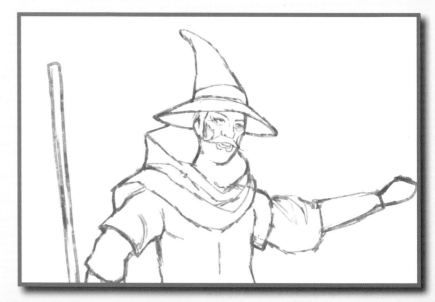

14 Draw in his long beard and lots of hair. Give the hair movement by drawing it flaring out at the sides. Draw his beard bulking outwards from his chin and tapering towards the end. Make sure your pencil is nice and sharp for this finer work and don't press too hard so that you can erase any mistakes you make.

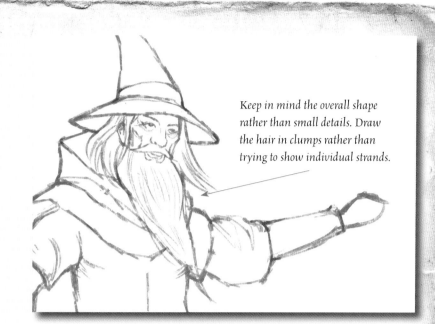

Keep in mind the overall shape rather than small details. Draw the hair in clumps rather than trying to show individual strands.

15 Draw a line across his chest to suggest another short tunic layered over the others, cropped at chest level. This just provides a bit more detail on the torso. Following the curve of his calves and shins, draw crossing lines to depict the bindings on his legs.

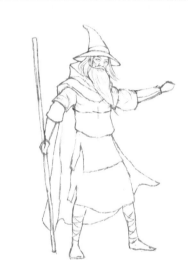

16 Work all over the drawing adding marks to show folds and creases in the cloth of his costume. Draw two parallel lines diagonally across his middle and another line below the waist to show straps and a belt. Draw in some pouches at his hips, making the one on his right hip a box shape and the one on his left hip more rounded.

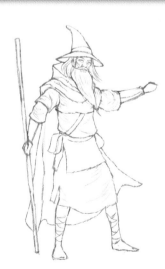

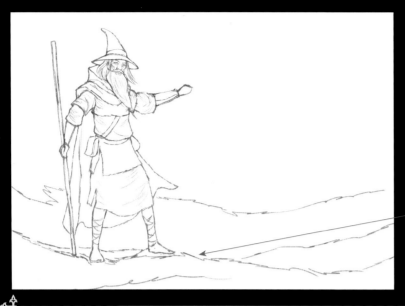

17 With the figure almost complete, you can now add a setting. You don't want the background to take too much focus away from the wizard, so keep the setting fairly simple. To begin with, draw a few jagged lines across the width of the page to create a quick moorland landscape.

Start at the bottom of the drawing placing the first jagged line below his feet, a couple of lines converging under and around his feet and the final line around knee level.

18 Add some simple standing stones by drawing a couple more jagged lines with the stone shapes jutting out of them. These will help to give the setting more atmosphere and tell more of a story about the character.

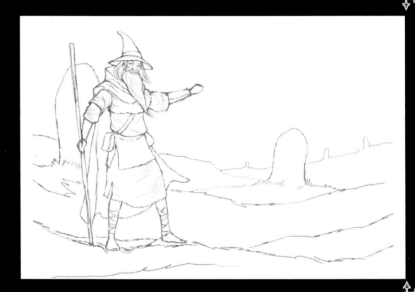

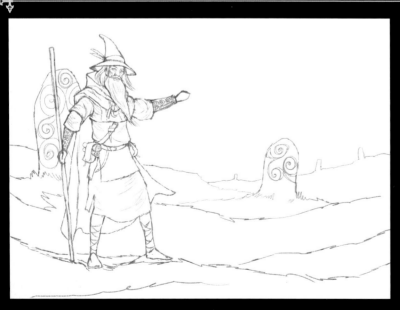

19 Draw a few swirls to add interest to the standing stones. Add more refined details to the pouches and straps – some scrolls amulets and buckles. Draw some spirals on his forearms to make an interesting pattern and finish off his hat with a couple of feathers.

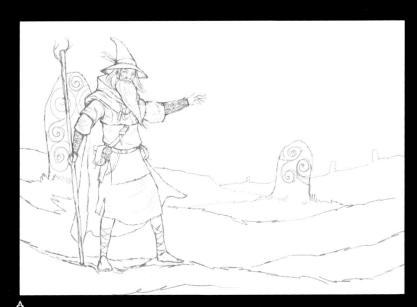

20 Continue working up details until you are happy. Add some shading to his sleeves and a few branches coming out of his staff. Finally, erase the guide for his hands and draw these in properly. You will almost certainly need to use a reference photo for this to get them looking realistic. Your wizard is now ready for painting!

21 Break out the paint and splash in some really loose washes over everything using big brushes with earthy tones and fresh greens. The aim is to get rid of the flat white paper and start laying down something more interesting to work on – nothing too dark, nothing too brightly coloured.

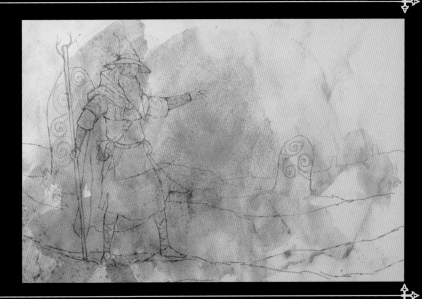

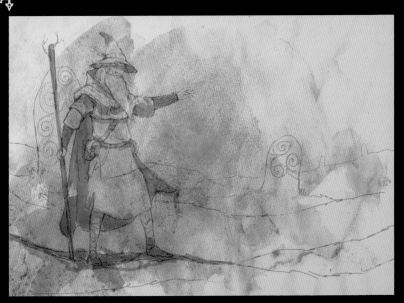

22 Using a large brush and a grey wash, start to put in some initial shadows. As in the previous demonstration, the lighting in this image is ambient (see page 28) but primarily falling from above. Shadows need to be placed in areas that the light will not directly hit. For example, the brim of his hat casts a shadow on his face, the inside of the cloak is in shade, and a shadow area is formed under his hood.

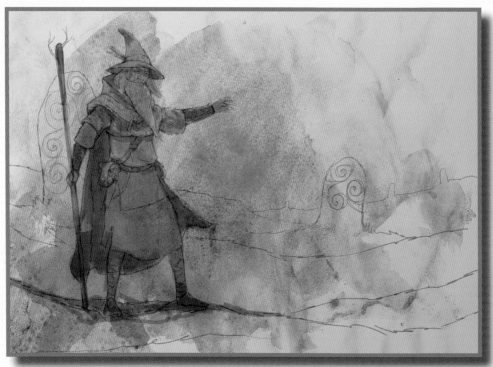

23 You now need to darken the figure as a whole to make it stand out a little more, so lay down a more or less flat, slightly darker grey wash on to the figure. This does not need to be too accurate at this stage, you can work quite fast and loose with big brushes.

24 To make the figure stand out even more take some fairly opaque paint in a blue-grey sky colour and paint around the wizard with a medium brush. Carefully blend it outwards in thinner layers and smudges so that it doesn't end abruptly. Suggest some clouds by leaving bumpy ragged edges.

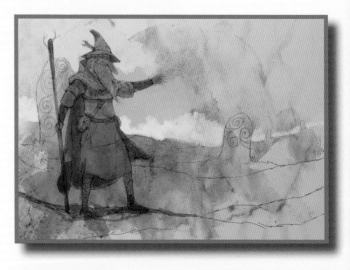

~tip~

When painting clouds it's amazing how little brushwork you actually have to do. Experiment and practise producing different cloud effects quickly and easily.

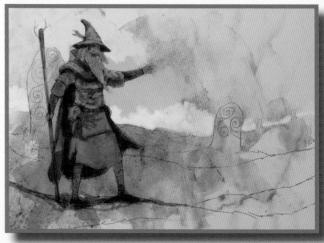

25 Add another round of washes on to the main figure, some overlapping the existing shadow areas to make them darker, and some in non-shadow areas to break them up with a variety of tones. The base you are going to paint on to needs to be fairly dark. There's no rush – washes work better when they are built up slowly.

26 Using a medium brush, add some midtone grey to his clothing. Use a fairly opaque paint to cover up the wash but don't totally obliterate it – it's good to let some of the wash areas peek through from underneath so that your colour isn't just flat.

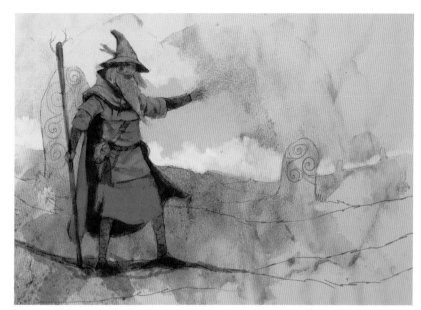

27 Take a midtone flesh colour and roughly paint in his face and hands. Over the washes this will probably look a little dark and purply, so go back in with a slightly lighter and more orangey flesh colour to build some highlights on his cheekbones, the bridge of his nose and his knuckles.

Don't be tempted to use a very fine brush yet. Keep things fairly loose to promote those 'happy accidents' that can bring an image to life.

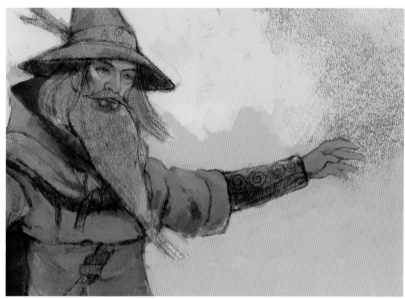

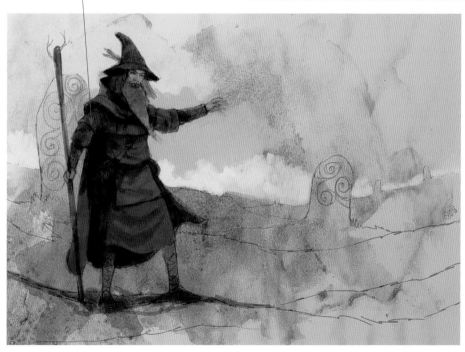

28 Go back to the clothes with another grey wash and a medium brush to build up more detailed shadow areas. Place this wash quite liberally across the clothing – under the hood, down his arms, across the skirt section of his tunic. This gives you plenty to work on top of with opaque midtones in the next step.

29 Using an opaque mid-grey and a medium brush with a good point, cut into the previous wash with some strong triangular and diamond shapes to show the folds of the fabric following the curves of the figure. Pick out where the light hits his clothing on the upper chest, across his abdomen and on the skirt area. Do the same on his arms and hat with a small brush.

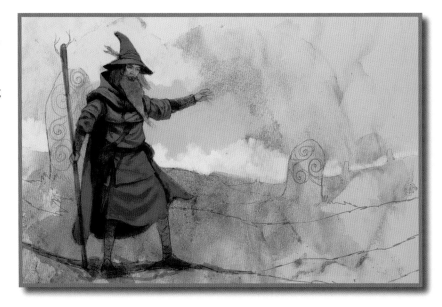

30 Take a smaller brush and some mid-grey and neaten up the folds painted in the last step with sharper points to the triangular shapes. Apply a chestnut brown wash to all the leather areas and lay a simple wash of the same colour across the wizard's eyes to show the shade his hat is casting.

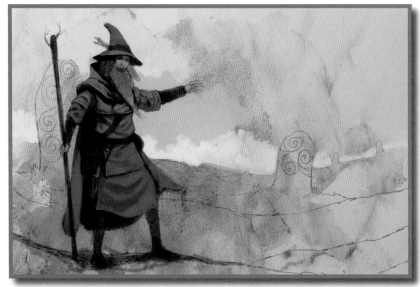

~tip~

You can really speed up your painting by using the same washes for multiple uses. Scattering the same colours around the painting also helps the flow of your image.

31 Add some brown highlights to the leather areas with a lighter brown and a small brush then wash over the beard with the same brown colour to get rid of the somewhat greeny colour. Take the time to have a clean up, neatening round the shapes with a little of the relevant colours and a small sharp brush.

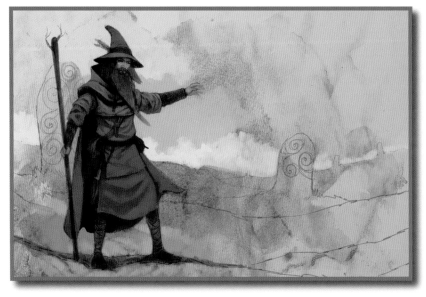

32 Continue working on the beard, adding some grey using a very fine brush to give the effect of strands and clumps of beard and hair. Then add some darks to the beard with a grey wash at its roots, under the wizard's nose, and at the tip to give it volume. Finally, add some highlights to the beard and hair with a paler grey, picking out some individual strands.

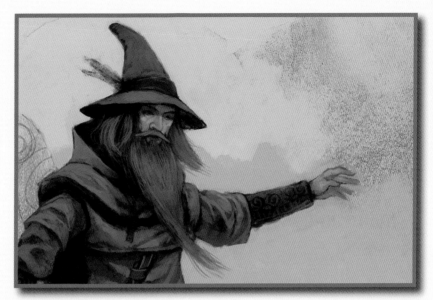

33 Look around the image to see which areas are lagging behind. His feet, staff and hands all need attention. You will also be aware of various details from the drawing that haven't been given much attention yet, such as his pouches and scrolls. First, paint some more opaque background colour around the edges of his hands and feet to tidy them up a little.

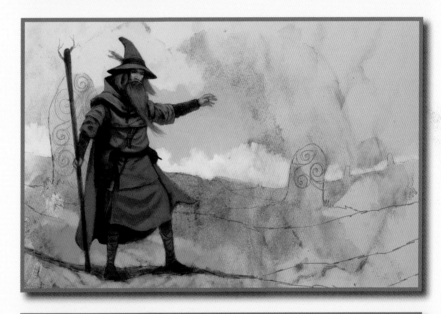

34 Paint over the staff in a dark brown and then paint on some highlights with a very fine brush to show the wood grain. If you make a mistake or the edges get a bit rough looking, paint around the staff with opaque background colour to make the edges crisp again.

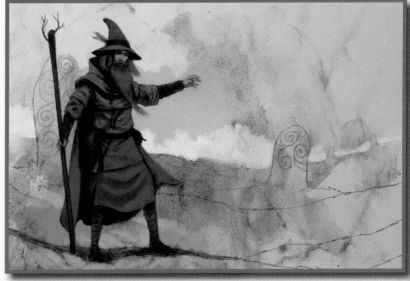

35 To ground the character in his setting, paint in some stalks of grass around his feet using a flicking motion with a fine brush and a dark green colour. A few little details like this will stop him floating, which will make the image appear much more convincing.

36 Paint in his amulets in a dull base gold colour and give him a nice gold belt buckle. Paint in his scrolls with one suitable parchment colour for now to keep them simple.

37 Touch in some bright highlights on the gold in a bright yellow but don't get too detailed – you want to suggest detail rather than slavishly painting it all in. Paint in the feathers in his hat very simply with one dark brown colour. Then use the opaque background colour to cut feathery shapes into them.

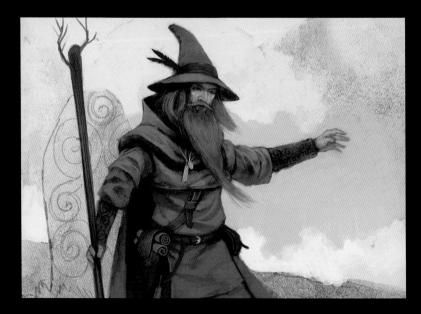

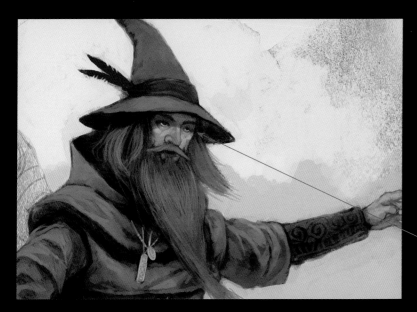

38 The focus of a character piece like this is the face, so now paint in the whites of his eyes with a pale grey-brown and wash a little pink on to his nose. Add a little more definition to his eyebrows by taking a fine brush and wiggling it around to make some bushy looking marks.

When painting in the whites of eyes never use pure white, as it makes faces very cartoon-like.

39 Paint in his pupils and irises with some darker brown. Observe real eyes – in life you rarely see the whole of the iris, and if you do it makes a person look very scared or surprised. Add a final tiny dab of white as a highlight in the eyes and then wash in a little bit of texture and shadow on to the standing stones in the background to finish the image.

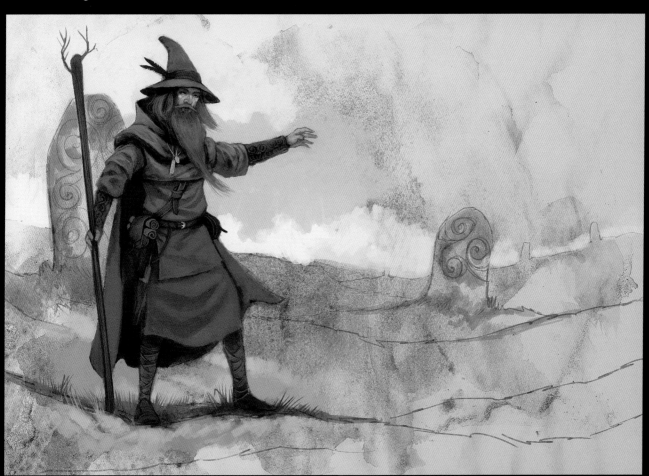

Crundale the Wise

Using the same techniques as in the steps outlined on the previous pages, and healthy doses of time, patience and practice, you can keep working on your image and take it to the next level of finish. In this professional-quality image, each area had more time spent on it, more care taken with the shapes of the midtone and highlight areas, more attention paid to the edges, more delicate washes added and more small details painted in. The background has been developed to add to the atmosphere of the painting, with mist clouds and circling birds creating a really spooky feel. Everything that you see here can be achieved using the techniques already described. The only wizardry is experience!

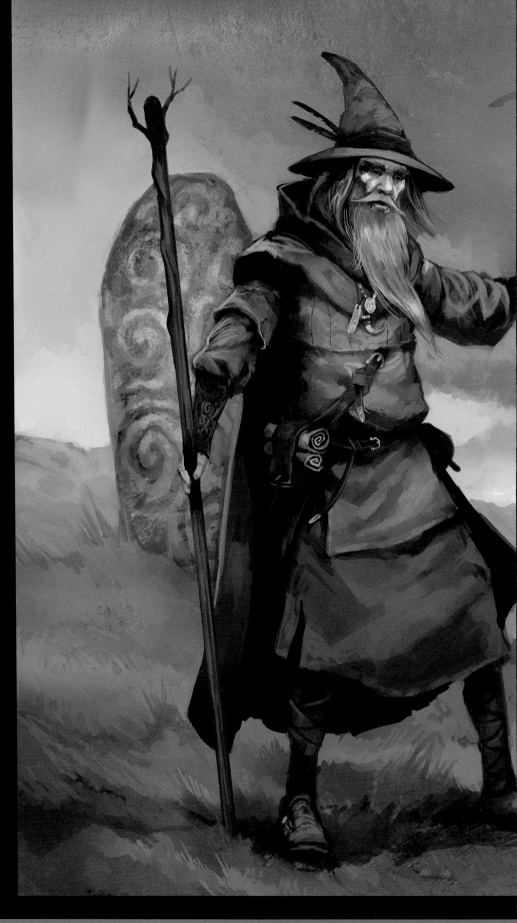

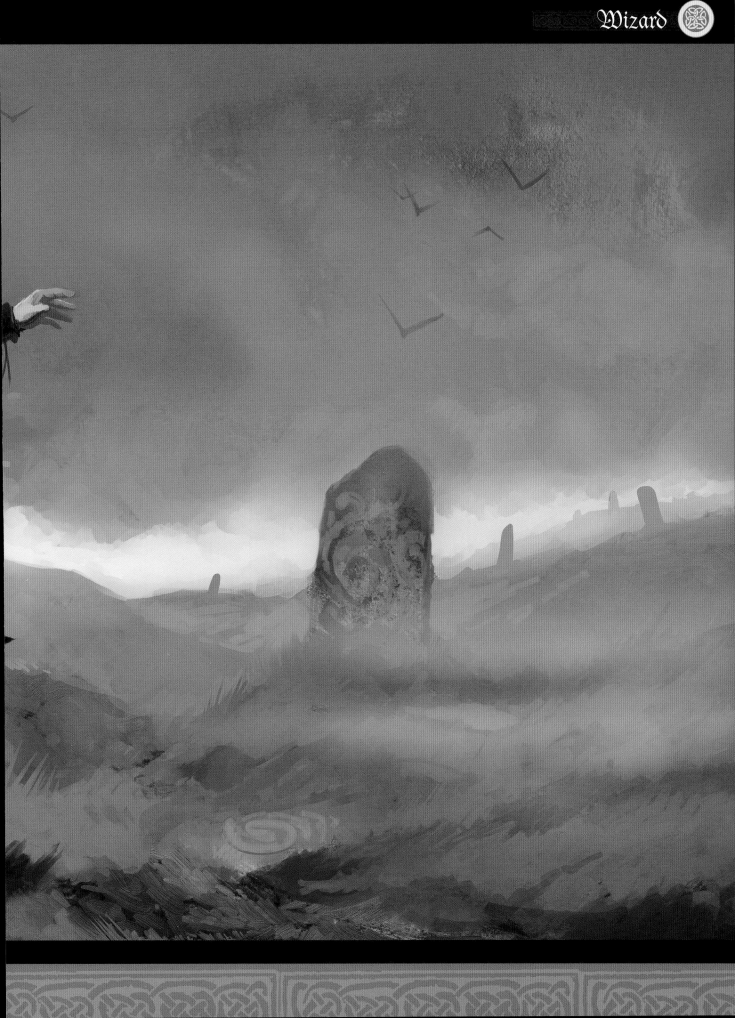

Monster

In fantasy fiction, monsters are symbolic creatures that present themselves as an adversary or force for evil. This demonstration shows you how to create a hulking brute of a troll – beginning with sketches to determine the design, then creating a line drawing and on into paint using earthy and iron-grey colours to create a dour, monstrous feel.

PREPARATORY WORK

As always, the process begins with sketching. Sketch as much as you can and as often as possible. Whether you have an image in mind that you would like to paint, or perhaps just for the fun of it, sketching is a worthwhile pursuit for a new artist. When you sketch you can very quickly work through lots of ideas and start to pin down what it is you want to do. In your mind you might have quite a clear image, but when you try to zero in on it, it is quite hazy. There are lots of different poses a monster could take, and innumerable body shapes. So before you commit to constructing a full-blown image, break out the sketchbook or scrap paper and do lots of quick drawings.

Hunched over. Crouched like a cave man. High-action attacks.

Horns will give an appropriate beast-like feel.

A long neck might make the monster look more otherworldly.

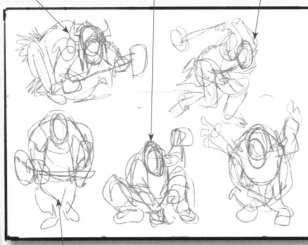

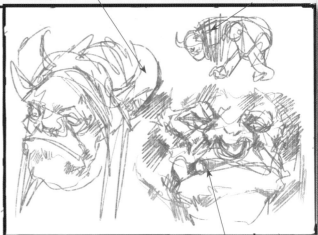

Brutal blunt features, massive chin, big teeth, ring through nose – great monster features!

Hunched but upright.

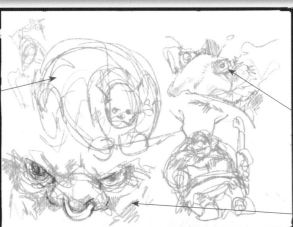

This hunched over, big bulky beast will make a great subject for the final image.

Try out different facial expressions – this is a cruel expression but not bulky enough.

This angry expression is perfect!

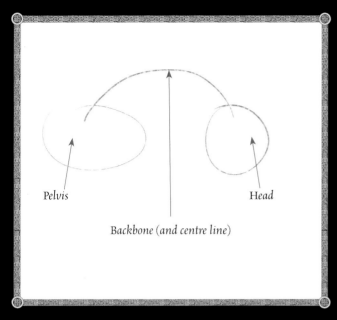

Pelvis

Head

Backbone (and centre line)

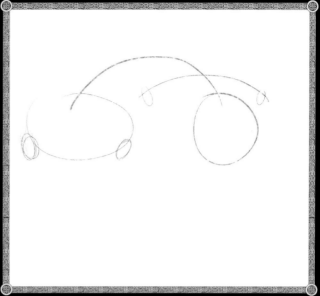

1 The first step when drawing any creature – man or beast – is the head. Draw a circle thinking about where the creature will be on the page, and making sure you have plenty of room to work with. Add a line to show the curve of the spine and an oval for the pelvis.

2 Add a line across the top of the spine near the head to show the position of the shoulders and draw a circle at each end of this line to show where the arms will join the body. Add two circles to the pelvis to mark the hip joints, where the legs will emerge.

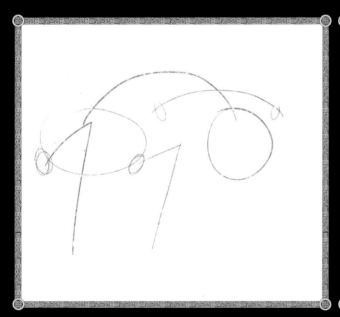

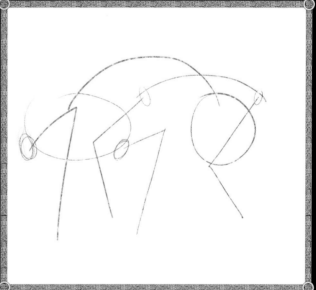

3 Draw in two simple lines to show the rough position of the legs. The creature is hunched over in a bestial crouch, reminiscent of a cave man, so his legs are deeply bent at the knees.

4 Add two lines show where the arms will go. Even though his left arm will be obscured by his head, it is still important to draw this in so you know where it is placed. The creature will be holding a big hammer, so place his arms with this in mind.

5 Draw a circle on the end of each arm to show where his big hands will go. Add a simple line between the hands to indicate the position of the monster's weapon. Add a roughly semi-circular shape to the end of each leg to form simplified feet.

6 Draw an oval shape around the hip circle and leg line for the monster's right thigh, and another elongated oval shape from the bend of the knee down to meet the foot for the lower leg.

7 Draw in larger circles around the smaller guide circles for the shoulders. To avoid the drawing becoming too confusing, on his left shoulder, you only need to draw the parts of the shoulder that will be visible, so make this a semi-circle rather than a full circle.

8 Draw an oval shape for the upper arm and another for forearm. On his left arm, draw a partial oval to show the parts that will be visible.

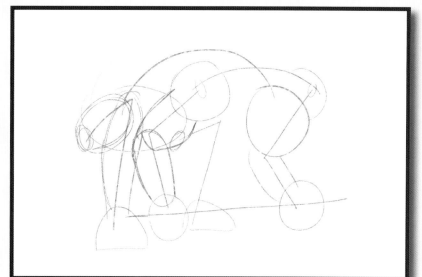

9 Quickly sketch in a big bulky, bean-shaped body starting below the right thigh and following the curve of the spine round to the edge of his left shoulder. Add two small curves underneath the body to show the chest and tummy.

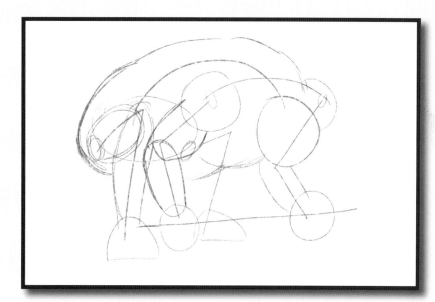

10 Draw in his left leg following the guide. Erase the unnecessary construction lines to make the drawing less confusing, then strengthen the outlines by going over them more firmly with the pencil to make the drawing clearer.

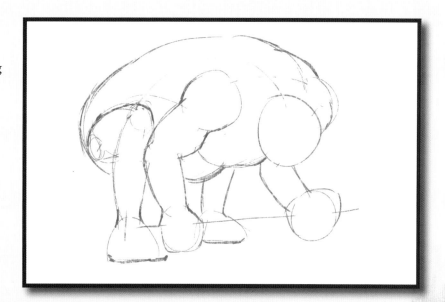

11 Put some segments on his body to show form by drawing curved lines around the body. To do this you have to imagine the creature as a three-dimensional object. Add some humped curves along the monster's back to show his spine and emphasize his crouched pose.

Drawing 3D shapes gets easier with practice – it may take you several attempts to put in lines that look right.

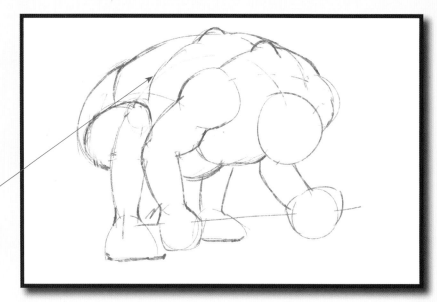

12 Draw a cross on the head as the starting point for the face and place the eye sockets on the horizontal line with roughly one eye's space between them.

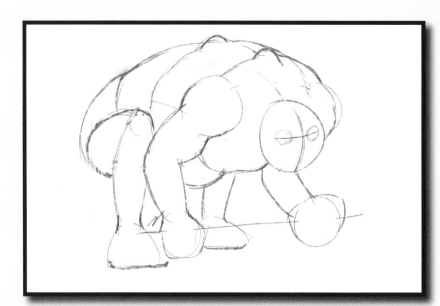

13 Add a big monster nose and a large curve across the lower part of the face for a huge, down-turned mouth.

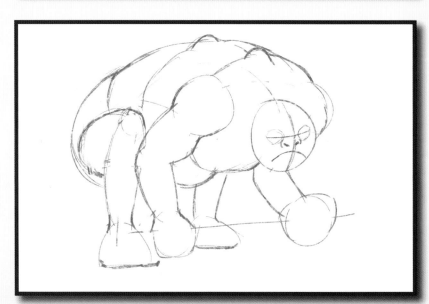

14 With the facial features in place you can erase the cross on the face. Add a couple of quick lines to indicate the cheek bones and some large ears coming straight out of the side of the head, tapering to a point. Start to refine the shape of the head by squaring off the jaw slightly.

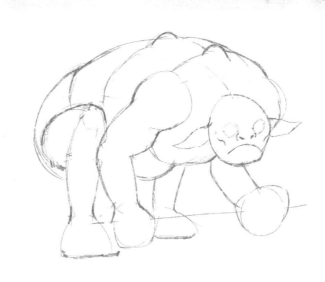

15 Continue refining the shape of the head and draw in a semi-circle behind it to show the neck. Draw in some big curved horns on either side of the head, just above the ears.

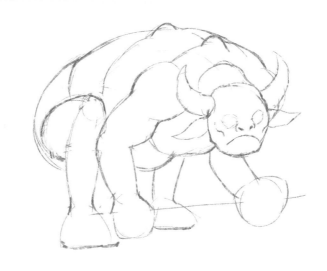

16 Plot in the basic outline for his monstrous mane. The hair will frame his face and fall on either side of his head behind his ears and horns with a few strands hanging in front. The mane will cover his neck area and part of his back too.

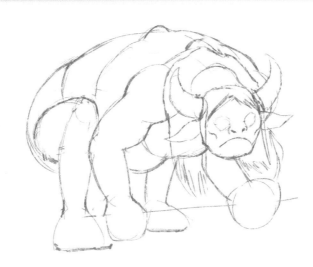

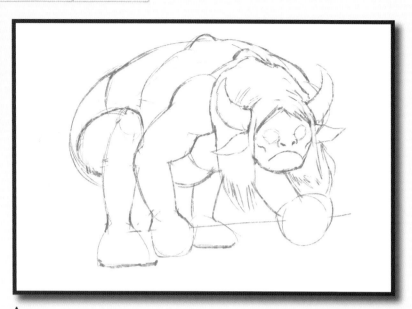

17 Erase the body parts that are obscured by the hair, safe in the knowledge that you have constructed everything underneath it properly and it needs no more work. Add a few more lines in the hair to give it slightly more detail.

18 Add some facial details to bring his face to life. Give him small, piggy eyes, a deep set brow, a nose ring, creases down his ears, texture on his horns, a more defined lower lip, gnarly teeth and more definition in his jaw. As a guide for the construction of the hands, add three small circles to each to indicate the knuckles.

The monster's left hand grips the weapon from underneath so the knuckles are at the bottom of the shape.

His right hand grips it from above so the knuckles are at the top.

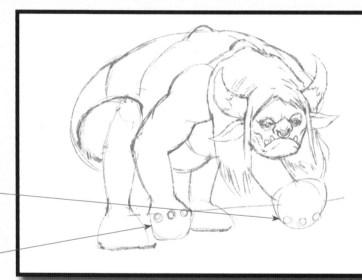

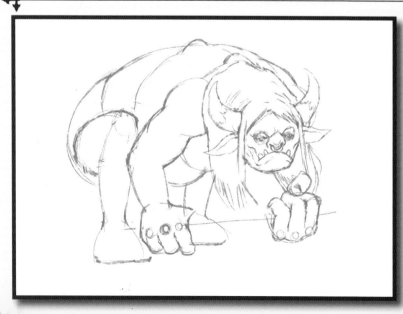

19 Ideally using a reference photo of real hands, carefully draw in the fingers wrapped around the weapon. Observe that fingers do not run parallel, they twist and overlap. Your reference will need to be distorted to give him just three fingers and a thumb. Draw the thumb of his left hand on top to complete his grip, with his right thumb disappearing behind the shaft of the weapon.

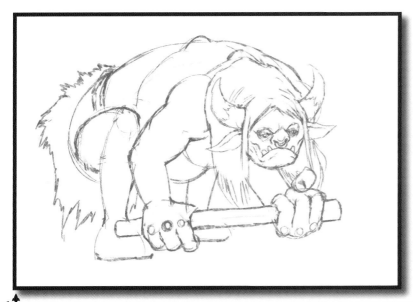

20 Following the construction line, bulk out the shaft of the weapon so that he has something solid to grip. Add a fur loincloth to the back of the monster and just visible through his legs. It is important to vary the textures in an image, so this furry texture provides an ideal opportunity for that.

21 Start to refine the leg, erasing the knee construction lines and enhancing the shape of the muscles. Erase the construction line around his bottom and start to put in a more realistic foot with four defined toes. Throughout the process, constantly refine the drawing by erasing unnecessary lines and putting down firmer pencil lines.

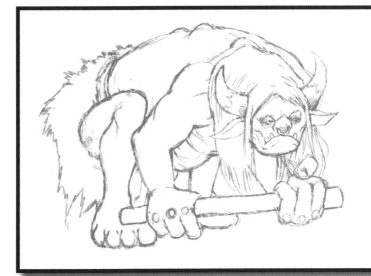

22 Carefully add some curved marks to indicate his ribs and overlapping muscles across his torso and back. Put in curves to show the three-dimensional bulging shapes that make up his body. These overlapping shapes help create the illusion of volume. This is quite a challenging process that takes practice. Don't worry if your initial attempts aren't perfect.

23 Add the details, such as his earring and wristbands, and make some marks on his knuckles and on his loincloth. Then draw in the head of his weapon. This is an important detail – a character's choice of weapon says a lot about them. This monster wouldn't look right with a rapier or a finely crafted Gothic mace. He needs a blunt instrument, perhaps one that he has made himself.

24 With the figure sketch mostly complete, you can add a setting. You don't want to take the focus away from the monster, so something simple is best. Draw an indication of rocks on the ground, which will give the image a cave-like or Stone Age setting, adding to the brutish character of the monster and giving the image an extra texture.

25 As a final touch, add some human skulls to show the scale of the monster. Refer to photographs of skulls and sketch out different angles in your sketchbook before transferring them to the drawing. Take a final pass, neatening everything up, erasing things you don't need, adding extra weight to important lines and emphasizing overlaps to add more depth.

Pause for a moment and look at your drawing as objectively as you can. Make any changes you need to now before you move on to painting.

26 Begin the painting process by splashing washes all over the drawing with big brushes. You don't need to pay close attention to what you are doing – you are not painting in shadows or following your lines – you just need to break up the white page with some initial colour and texture. Use earthy colours as a base with occasional splashes of greeny turquoise to add texture and interest. Add some extra washes at the bottom where the ground will be darker.

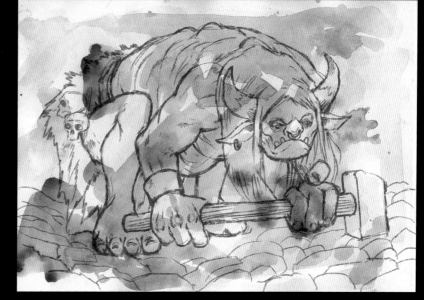

27 Using a greeny grey wash and a big brush, fill in the eye sockets, under his nose, under his lip, along the cheekbones, in his ears and under his hair to show the basic shadow areas with the main light source somewhere above. Don't worry about being too careful – this is underpainting, and you will revisit everything with more opaque paint later.

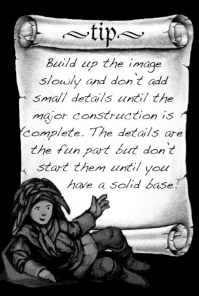

28 Continue with the greeny grey washes, adding shadow areas across his body – on his tummy, far leg, horns, far arm, hands, near arm and leg, hammer and toes.

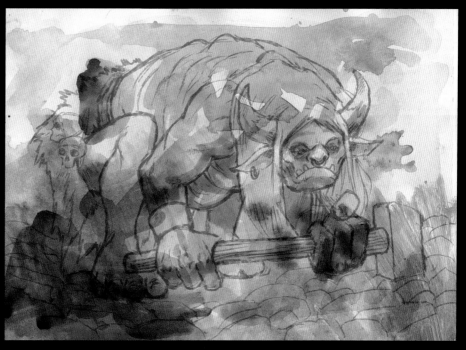

29 Using a darker brown wash with a medium brush, paint in his hair and loincloth. This is the first time you need to work carefully. You don't want any hair colour or fur colour to go on to his skin. The paint that is underneath this wash will give some variety of texture without you having to do any work at all!

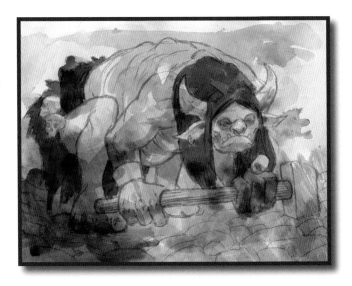

~tip~

Opaque paint is less forgiving than a wash, so you need to work with it carefully. Think before you put anything down on the paper and don't get too carried away.

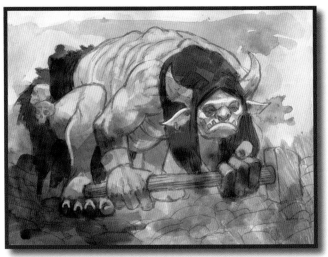

30 Move on to the highlights, using a fairly thin but still opaque paint and a medium brush with a good point. Select a slightly lighter flesh colour than the base underpainting. Start off on his back and shoulder, carefully following the forms you created in the sketch. Carry on across the creature, picking out areas that are being hit with light from above, such as the cheeks, nose, shoulders, upper back and uppermost surface of the legs.

31 You now have all the basic forms described – your shadows and highlights are in, and the midtones are provided by the original wash. Step back and look critically at the tones. The monster is a bit pale and he needs to look browner and more weather-beaten so you need to add another wash. This will destroy some of your carefully painted highlights, but it is what the piece needs and you can't afford to be precious about it!

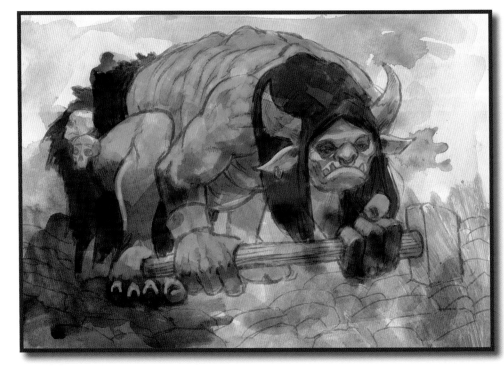

32 The background is looking a little too busy and it would be better to show more difference between the monster and the background. Break out the opaque paint and paint right up to the edges of the creature to carve or cut it out of the busy background. This leaves all the texture on the monster, drawing the viewer's eye to him.

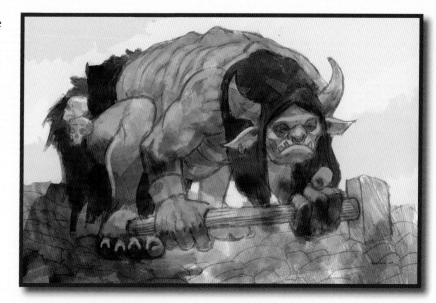

33 As you have seen in the previous steps, there are two different ways of making things stand out more or have more contrast. The first is to add a wash over the thing itself, and the second is to cut around it with a lighter colour. Using these techniques again, add another flat wash of grey-brown until you are satisfied he is dark enough and then neaten it up by cutting around the monster with background colour.

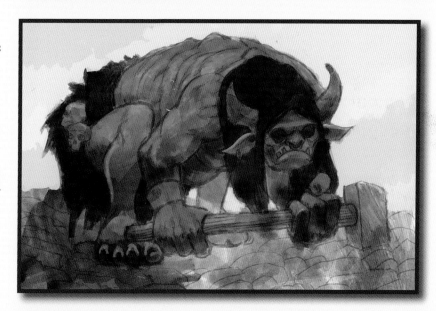

34 With the underpainting now done, the troll is dark enough in tone to revisit the earlier process of adding deep shadows, this time under his body, under his hairline, under his cheeks and nose and on the undersides of his bulging muscles. All the overlapping washes will start to build up some texture of their own, and really help describe the forms you are trying to show.

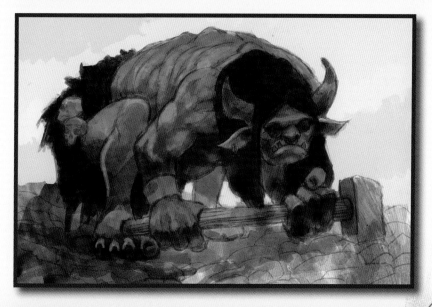

35 Add another round of midtones, creating lighter areas by overlaying semi-opaque paint on top of the washes using a small brush. Paint these across his brow, cheeks, nose, lower lip and the monstrous bags under his eyes. On his chin, use small stipply marks to create some obvious texture.

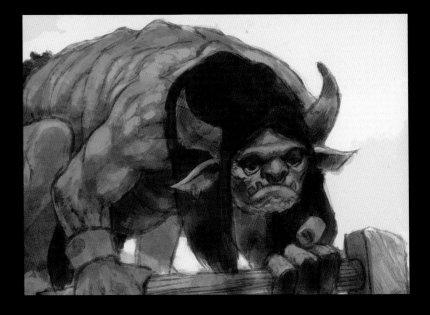

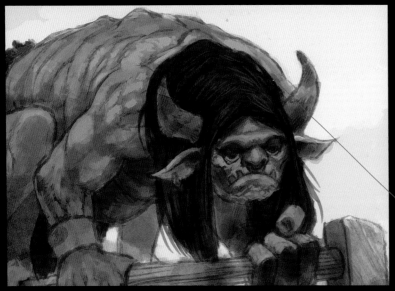

36 Rework the hair with opaque paint to get rid of any odd shapes caused by the random washes in the underpainting. Then use a dark grey-brown wash to add some linear elements to show strands and clumps. Use a slightly lighter opaque colour to add some highlights on the uppermost surfaces where light hits.

The hair should look very greasy and dirty, not shiny like clean hair, so keep your highlights minimal and don't use bright whites.

37 Repeat the same process as the hair for his loincloth, this time concentrating on short, tufty marks to show fur rather than long, linear hair strands. Think about the nature of the loincloth – as he is such a large creature his loincloth would be made of several animals' pelts so hint at overlapping, scruffy layers by painting in the seams and edges of pelts.

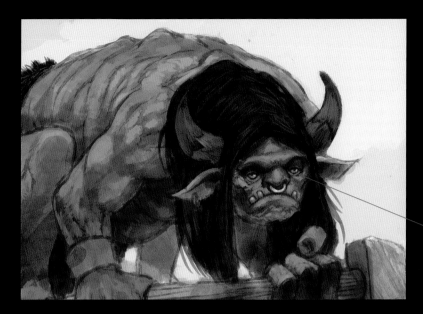

38 Tackle the horns using a wash for the darks followed by some carefully applied highlights in opaque paint with small brushes. Take a couple of passes with increasingly lighter colours. Paint the gold nose ring using a browny base, a yellow midtone and a yellow-plus-white highlight. For the teeth use a greyish yellow base and a slightly lighter grey highlight.

Paint the eyes in red and then add successive dabs of orange to make them look deep and liquid. A small white highlight will pop them into life.

39 Paint in his other accessories – the hammer, wristband and skulls – using a wash followed by opaque midtones and highlights. Do a final pass of highlights for super pop and a very quick and loose wash to throw some shadows on to the ground. Finally, take a last quick trip around the image with a small brush with very little paint on it to add some wisps of loincloth and tufts of hair with flicky marks to complete the painting.

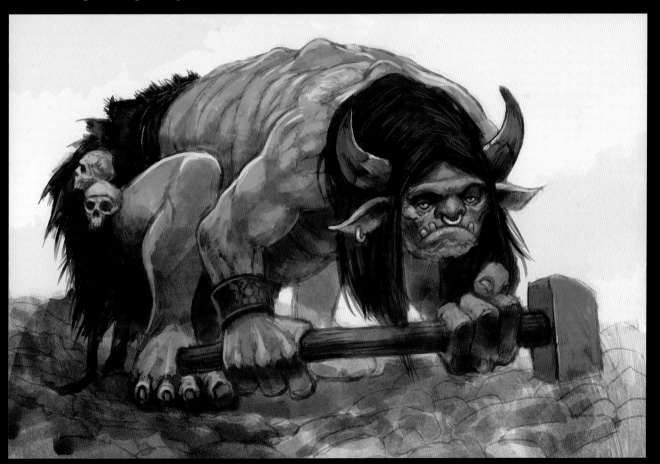

Rock Knocker Troll

Here you can see the painting developed to a more professional level. Using just the same techniques and a lot of time, care, experience and patience, these basic steps can be built on to make a highly polished image. The most important part of the process is the underlying drawing, as this builds the basic character. A refined finish like this comes from the luxury of experience, but the essential building blocks can be learned quite easily.

Heroine

The heroine is a staple of fantasy art – the gutsy female character that comes to the rescue of the menfolk. Often in fantasy art the female characters are scantily dressed, but a fearsome well-covered heroine is a much more dynamic figure. The techniques in this demonstration include constructing a heroically proportioned female figure and painting realistic armour.

PREPARATORY WORK

Begin with a bunch of lightning-fast thumbnail sketches working out how best to show a strong female character that is attractive but fierce. Try out as many ideas as quickly as you can. You want the image to be strong and simple and to tell a definite story. When you have decided on the pose, do some quick sketches of the head of the beast and the woman's face, both of which will be important in the final painting. You can get all sorts of ideas by just drawing what's in your head. Things go wrong, your pen slips and suddenly there's a new idea! It is well worth spending some time just doodling around the image you want to create before you dive in.

Victorious pose, leaning on sword with a dead creature.

Charging/attacking.

Resting.

Give some thought to her face – jewellery, expression, age and general demeanor.

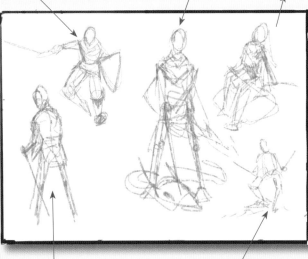

Seen from rear looking over shoulder.

Poised to defend.

Sketch out your ideas for the head of the beast.

The standing pose with the dead beast at her feet is a great composition for the final image.

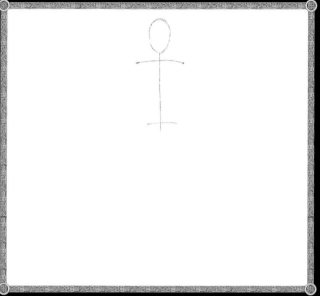

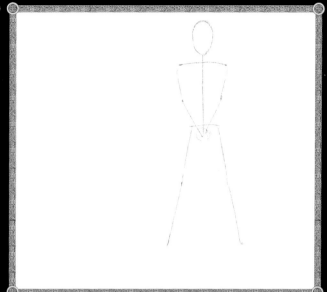

1 With an HB pencil, draw an egg shape for the head, thinking carefully about where it is positioned so that the rest of the figure fits on the page. Add a vertical line for the spine of the figure and two horizontal lines to show the span of the shoulders and the hips.

2 Add two lines for legs, bearing in mind roughly where the knees will go. Draw two lines for the arms converging in front of the figure. Give a slight indication of where the elbows will be and add a circle to represent the hands held together.

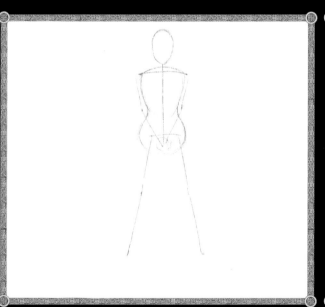

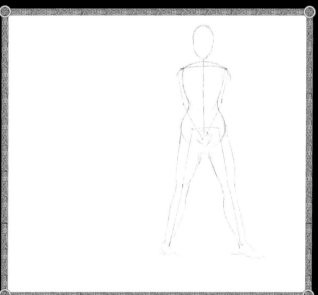

3 Even though the figure will be covered up, it is still important to compose the body underneath to make sure the armour looks right. Rough in a womanly 'hourglass' shape fitting around the shoulder and hip guides.

4 Draw in the legs following the construction lines and using a reference photo if you need to. Try to draw the shapes as accurately as possible. The thighs are widest where they meet the body and taper to the knee. The calves are shaped and then taper to the ankles.

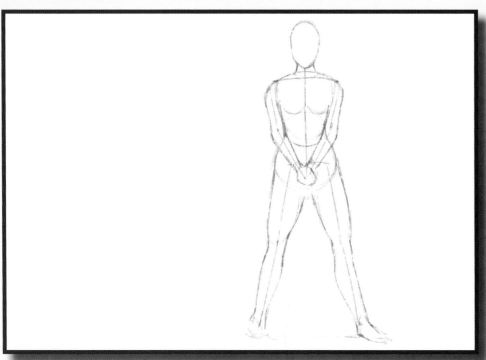

5 Flesh out the arms around the construction lines. To show the shape of the body, draw in some lines to indicate the chest and waist. You can see how this gives that blank torso area a lot more form. Add a neck to complete the initial figure work.

6 Erase all of the construction lines that are no longer required then plot in the head of the beast in front of the figure. It is important to work on the figure and the beast together rather than going too far with just one area, as this could leave your image disjointed.

~tip~

Draw lightly in the early stages to make erasing easy. Work carefully with your eraser, keep it clean and don't scrub the paper too hard.

7 With the head in place, begin to lay out the beast's body. Overlaps are vitally important to creating an illusion of space and depth in a drawing, so it will work well to show the beast's body winding back behind the heroine. Add some curved lines to its body to give it some fullness.

8 Continue drawing the beast's long body snaking around the figure and tapering to a point for the tail, remembering to use lots of overlaps. Carry on adding curved lines along its length.

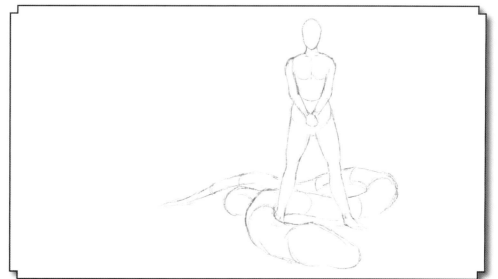

9 Draw in some irregular lumpy lines across the image to suggest a simple mountainous background and to stop the figure looking like she is floating. Add a few extra lines around the beast to give it a sense of resting on the ground.

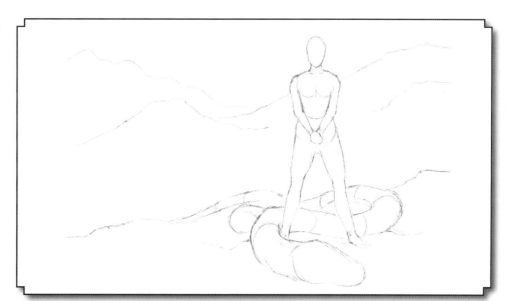

10 Draw in the basic outline of the cloak, which will be an important element to help frame the figure. Suggest movement in the cape by having it billowing out to one side. Draw in a fur collar to the cape going right around the shoulders and behind the head. Make this line spiky to really show the texture and add interest to the overall silhouette.

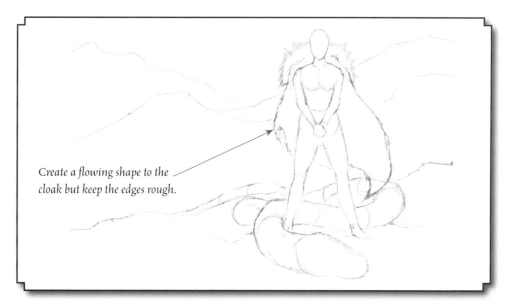

Create a flowing shape to the cloak but keep the edges rough.

11 Draw in an almond-shaped eye on the beast then start to build up the other facial features. Give it a sharp beak-like nose to make it look more aggressive. Extend a wiggly line from the bottom of the beak to form the mouth.

12 Add some horns to the beast's head, curving them outwards and tapering them to a point. Make the horns overlap the beast's body and the figure's leg to add depth. Add more detail to the beast by drawing lots of curved lines down his flanks to show his tubular shape. Carefully erase any lines that are no longer needed to keep everything clear.

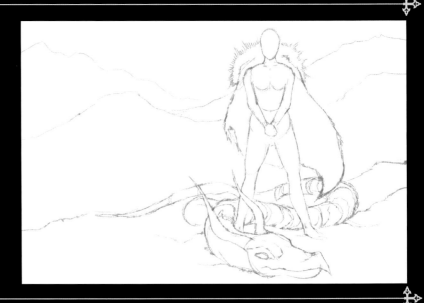

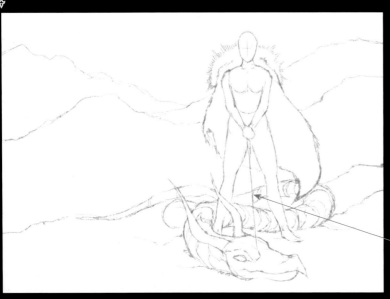

13 Draw a vertical line to indicate where the sword will rest on the beast's head. Draw a cross on the face to locate the major features. The eye line is about halfway down the head. The central vertical line for the nose is placed according to how tilted you want the head and what direction your character is looking in. Here it is central, as she will be staring straight ahead.

It is important to work out exactly where the sword will go before you launch into the intricate design of it.

14 With a light hand, sketch in the facial features. Until you are confident at drawing faces, there is no shame in working from a reference photo. Then very carefully erase around the facial features to remove the cross.

~tip~

When drawing a female face, every unnecessary line dramatically ages the face, so use the bare minimum unless you deliberately want to draw an old woman.

15 Rough in the basic shape of the shoulder-length hair. Think about the shapes hair makes – observing and sketching hair in real life is a good project for your sketchbook.

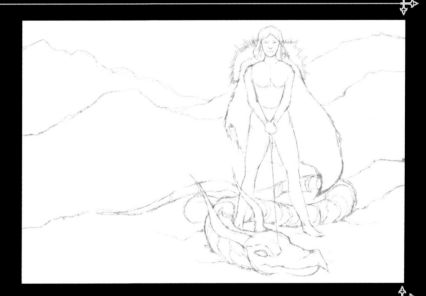

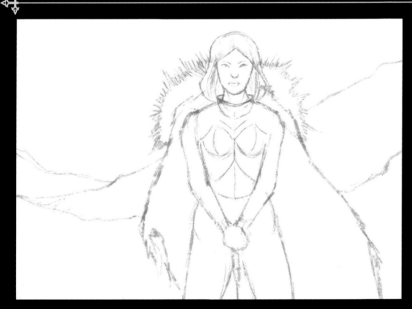

16 Start drawing in the armour, beginning on the torso with a neck guard and chest plate. Draw a curving, overlapping plate on the lower abdomen. Look on the Internet for reference photos of medieval armour to help you.

17 Keep building up detail on the armour. Using your reference photos as a guide, work down the arms and legs adding overlapping shapes to create an interesting plated design. Keep layering up the armour shapes and then draw in some boots by adding lines just above the knee and using a bit of shading around the kneecaps.

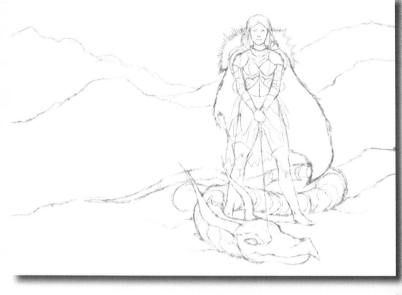

18 Continue adding more and more detail to the armour, stopping every once in a while to erase some of the construction lines. Work up the head of the beast adding detail in his eye, teeth and some gentle shading on his face and horns.

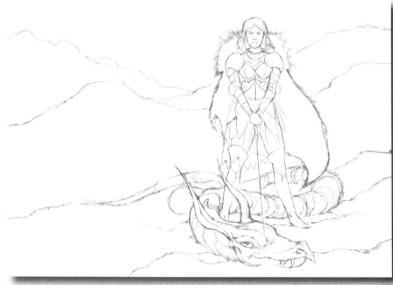

19 Keep working up the details across the image. Add a headband to the figure to draw attention to the face. Add small circles at her shoulders to show brooches that attach the cloak to her body. Draw in a broken shield lying on the ground on the left of the frame, which will add narrative to the image, telling the viewer that there has been a struggle.

On the details you want to keep, press harder with the pencil to make the lines more definite.

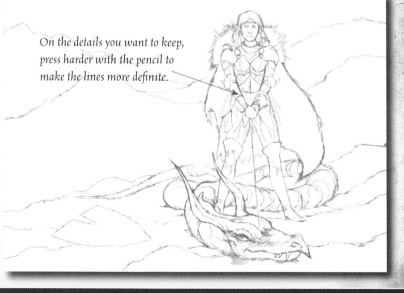

20 Add the final details of her fingers, some extra spikes on the armour, her sword's sheath slung diagonally behind her and a basic design on the broken shield and you are now ready to start painting.

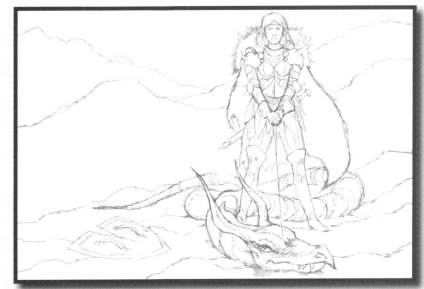

21 Apply a varied wash of very dilute earthy browns and warm pinks with big brushes over the entire drawing. You are not trying to draw or describe anything with this wash, you just want to cover the white page and create a nice textured base to work on.

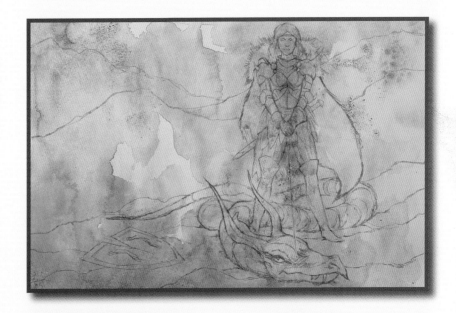

22 With a browny grey wash, fill in the main elements and loosely suggest the background with a simple flat wash that hints at some rocks and a horizon line. When the first wash is dry, with the same wash put in some of the deep darks on the figure, thinking about the areas that will be in shadow – all the nooks and crannies, the places that are turned away from the light, which is coming predominantly from above.

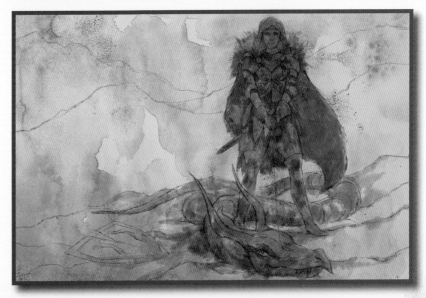

23 Lay in some washes of colour. Red for the beast, a bluey grey for the armour, brown for the boots and orange for her hair. At this point the painting looks terrible, but don't worry, these initial washes will all be worked over to create the final image.

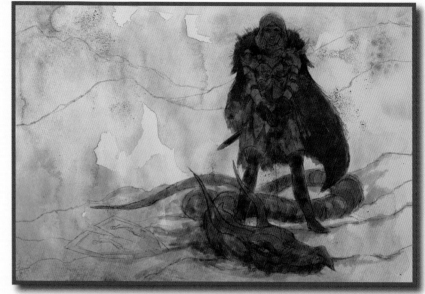

24 Begin to lay in what will become the midtones on the beast, using a mid-range pinkish colour and making quite jagged marks to build up some texture. Add some midtone areas to the armour too with a medium brush and a steely grey colour. Because the pencil sketch underneath is clear, it should be quite easy to make your marks follow the correct shapes.

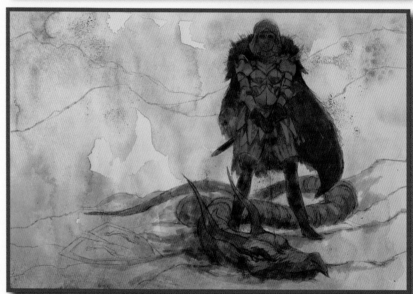

25 Using a medium brush, apply a dark grey wash to the cloak. Add a brown midtone to the gloves and put some flesh colour on the face.

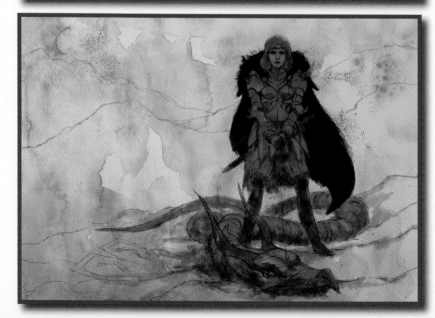

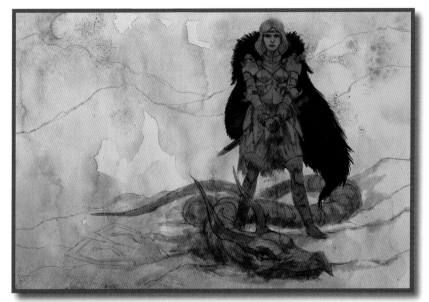

26 Add an orangey brown midtone to the hair using simple curved shapes. Using opaque dark brown paint, sharpen up the furry silhouette of the cloak and its collar. Use long flicky marks to simulate jagged fur.

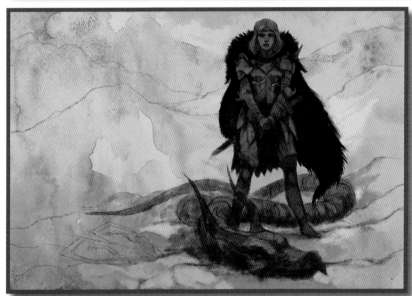

27 With the midtones in place, apply another set of washes, using a greyish version of the underlying colour – so a greyish brown on the leather boots, a greyish red on the beast and so on. This will add the appearance of volume to the shapes. Then crisp up the figure against the background by using some of the background colours with a sharp, medium brush to paint tightly up to the edges.

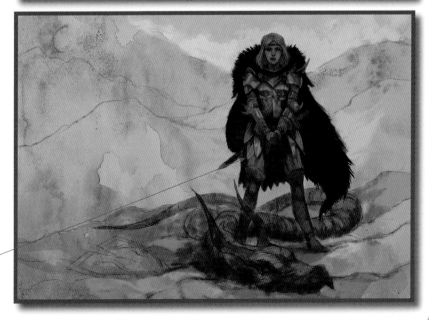

28 Make the background a bit less beige by washing on some greys and greens for a cooler 'rockier' look. Everything is now quite midtone so start applying highlights to the armour to help the image 'pop'. With a fine brush, take a light grey with a touch of blue in it and go around the forms picking out areas that are turned towards the light.

When painting metal, make your highlights quite sharp and pick out edges with crisp little lines.

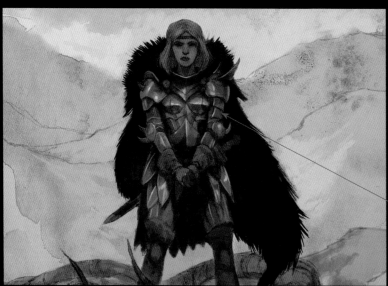

29 Do another pass of highlights on the armour, this time using almost pure white to really make them 'zing' and give a truly metallic appearance. Paint over a portion of some of the previously added highlights to blend them to bright white. Add some sharp highlights to the edges and joins of the armour to make it look hard.

Work carefully and pause regularly to check that you are not overloading the armour with too many highlights.

30 Using a lighter flesh colour, paint in her almost triangular cheeks, thinking about the bone structures underneath. Look at photos of women's faces in different lighting if you need some help with this. Add a very simple bar of lighter colour for her nose, flaring it slightly at the tip.

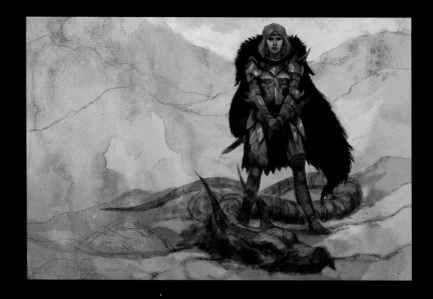

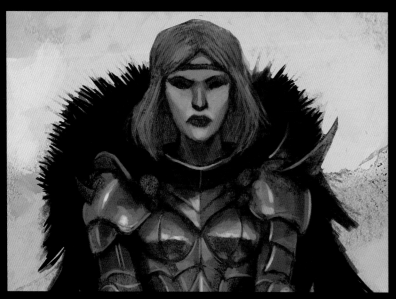

31 Carefully paint in some highlights on her forehead, leaving the darker colour underneath showing through to give the effect of a shadow from her hair. Using a fine brush and some lighter flesh colour, paint in her chin, correcting any lopsidedness in the mouth as you go.

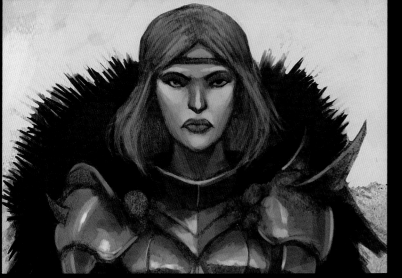

32 Using a fairly dark grey, paint in the whites of the eyes. Add another wash on the hair to bring it up to a similar level of finish as the face. Add another round of highlights across the cheeks and nose. Paint in her lips with a slightly more red skin colour and carefully emphasize her eyes with thin black outlines. This will take a very fine brush and a steady hand.

33 Now go back to the beast. Add some highlights in a lighter colour and neaten up the eye, mouth and tips of the horns. You are not doing anything terribly complex here, just neatening things up, making them clearer and adding contrast with lighter highlights. Paint in the teeth with a dull grey and then add lighter highlights.

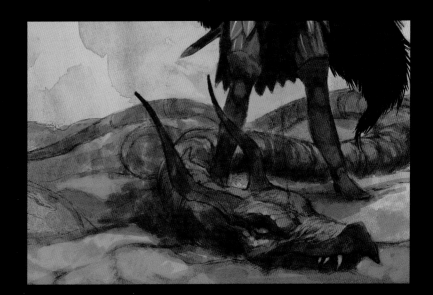

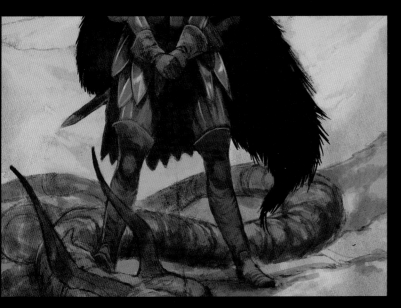

34 Add some highlights to the gloves and the boots with a lighter brown and a small brush. Working in this way – adding progressively lighter highlights on top of a darker midtone – makes things appear sharper as the highlights emphasize the shapes they are lying on.

35 With a fine brush, paint in a dull yellow-gold colour on to the brooches for her cloak, her headband, her belt buckles, sword pommel and scabbard adornments.

36 Add some highlights to the gold areas in a light yellow, then add a second round of highlights in a really sharp white on top of the first set. Experiment with placing the highlights in the middle of the previous highlights, or slightly to one end of the first brush marks. Apply some stronger highlights on her hair in a lighter shade of the auburn colour then add in some strong green for her eyes. Add a final white highlight with the point of a very fine brush to complete the eyes.

Paint in the eyes with a mid-green, then dab in some lighter green at the bottom of the irises to bring them to life.

37 Paint in the sword. First, lay down a long pointed rectangle of flat grey colour with a fine brush then flatly paint in a crosspiece and grip in a golden yellow colour.

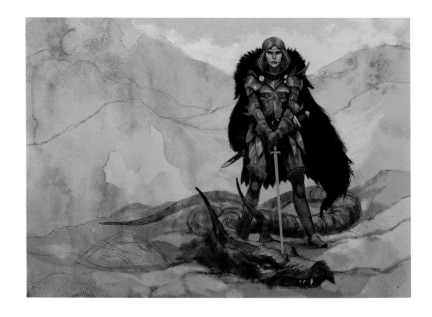

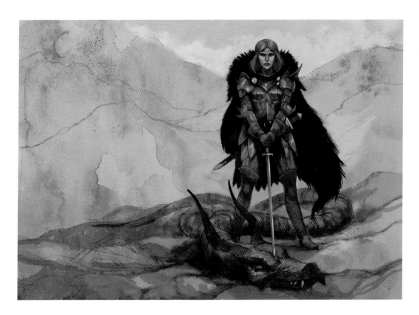

38 Apply washes in the relevant colours to add some quick shading to the blade, crosspiece and grip of the sword. With these washes to hand, run a little bit of washy colour around the background to create some more defined rocks and to darken up the shadow where the beast meets the ground.

~tip~

It is very tempting to rush to finish a painting, but a last careful polish, made up of dozens of tiny little adjustments is well worth your time.

39 Highlight the sword with some white-grey on one side of the blade. Carefully sharpen up the edges of the figure and beast. Add a few delicate reddish washes to her cheeks and nose to add some colour. Use a pale grey wash on the armour to intensify the shadows and neaten up the edges with more highlights. Add some highlights on the rocks in the foreground in rough shapes with a flat, square brush and wash in the broken shield to complete the image.

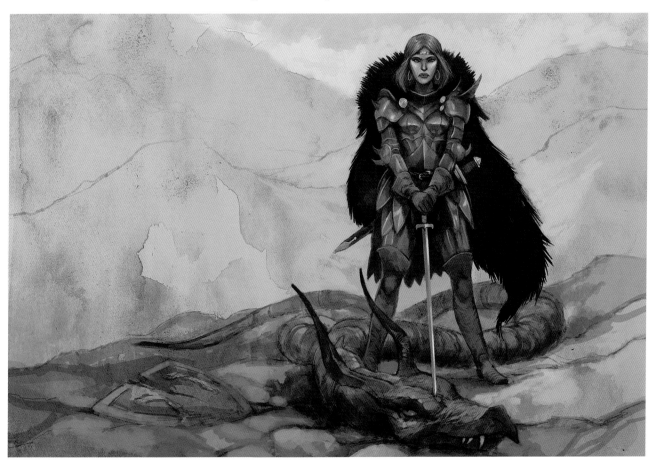

Amathena the Slayer

Once again, here is the image polished up to a higher, more professional level using the same techniques. Once the basic demonstration was completed, smaller brushes were used to do additional passes of finer and finer marks. Further washes and highlights enhanced the armour, and lots of attention was given to her face, including the addition of some stylized up-lighting and make-up to give her a more otherworldly and daunting look. None of this requires any further techniques than those shown in the preceding pages – it is all a matter of practice and perseverance, combined with lots of observational drawing and painting to learn as much as possible about lighting and landscape. In this image you can see how a solid setting can bring the story of your image to life.

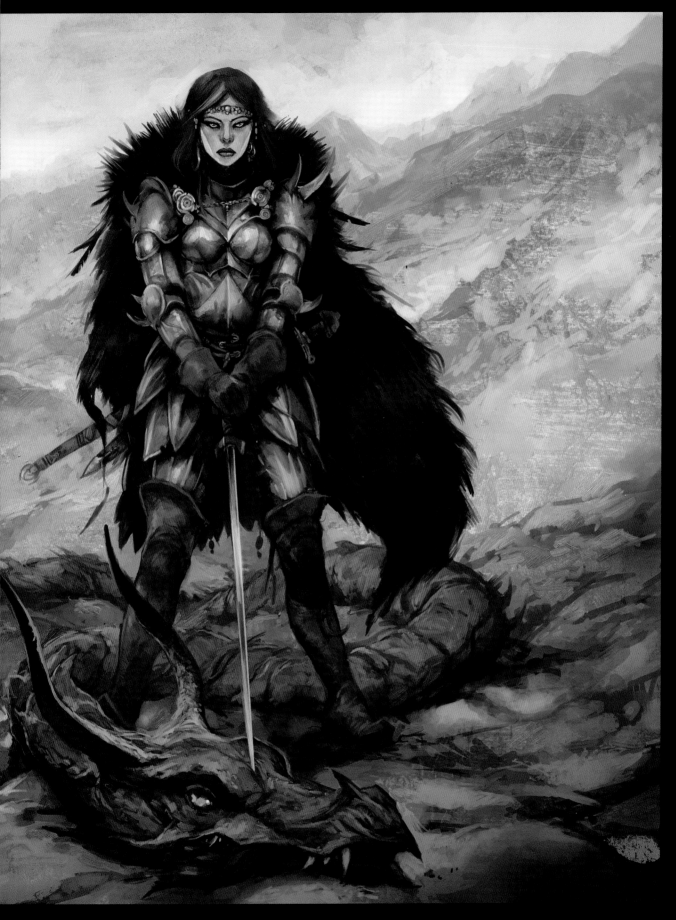

Faerie

The diminutive dwellers of the other world are an essential part of the fantasy genre. Fairies are creatures of the woodlands and are strongly linked to the earth, so lots of natural earthy tones will feature in this image. The techniques include drawing a delicate-looking figure, painting believable wings and giving a rough feel for a background.

INSPIRATION

With a subject like this it is important to identify your aims early on. Sometimes it's good to be as original as possible and wow your audience with ideas they have never seen before. At other times it can be better to meet your audience's expectations, and painting a faerie is one of these times. You don't want to reinvent the wheel – you want to make a nice painting of what people expect when they think of a faerie: a tiny young woman with pointed ears and butterfly wings.

However, as an exercise, it's worth a few thoughts at least in the other direction. What other kinds of faeries are there? How could you play with the expectations and create something new and exciting? You could swap the young woman for an older woman – a grey-haired faerie with accoutrements that show knowledge and experience. You could paint a male faerie, basing it either on one of the more common male goblin archetypes, or by designing a male

butterfly-winged faerie. Equally you could play with the idea of the butterfly wings. Why do faeries have these? To show they are small? Because they are simply beautiful? What about other insects' wings? Dragonfly wings can look wonderful too. How about bat wings for a malevolent faerie? Or dragon wings?

REFERENCE

Fire up the Internet, open up any books you can find about animals and plants, and have a look through your own collection of photographs to start finding reference images that you can use. Mushrooms always seem to go hand in hand with faeries so start with these. Then look at butterfly wings and all the different varieties and patterns that you could draw from. When you have found some suitable references, make some initial sketches from them.

◀ **Wing sketches**
It might be tempting not to sketch out your reference images and instead just plan on copying them into the final piece, but the better you know your references the better your image will be. By sketching them you will become better acquainted with them and can learn a lot to help you in your final image.

◀ **Toadstool sketches**
Gathering reference photographs or sketching from real life is invaluable. The stem and gill structures of toadstools are too complex to draw from your imagination or memory alone. If you want them to look lifelike you have to draw them from life!

THUMBNAILS

Put down some very rough ideas, choosing a pose and starting to think about some kind of setting. Because the subject matter is quite simple there is a danger that it will be boring, so it will need to feature some fine work and detail, particularly in the faerie's face, in order to be interesting. The pose needs to be spot on to show the delicate nature of the subject, and that means careful planning and construction.

Thumbnail 1 ▶
Try out a couple of initial poses – a faerie seated on a toadstool and a flying faerie in an open pose.

Thumbnail 2 ▶
Work up to a more active pose with a tilted head and an indication of flight. This composition seems to be the best. It has the most scope for an expressive pose, the most interesting body shape and you can really do something with it.

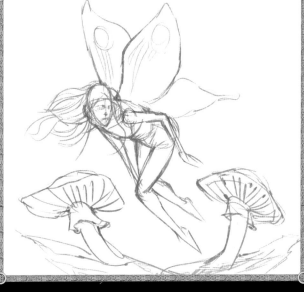

Rough sketch ▶
When you have decided on the basic pose, work up a slightly more detailed but still rough sketch. Don't worry if your sketch doesn't look as good as mine – I will show you how to construct all the elements step-by-step on the following pages!

1 The first thing to lay down is always the head – use an HB pencil to draw in an egg shape. This gives you a solid place to begin and positions the faerie on the page. Then draw a curved line that shows the location of the faerie's spine and add two circles for the hips.

2 Add a line as a guide to show where the shoulders will go. A circle at each end of the line shows where the shoulder joints will be. Even though the far shoulder will be obscured by her head, it is still a good idea to know where it is in relation to the visible shoulder.

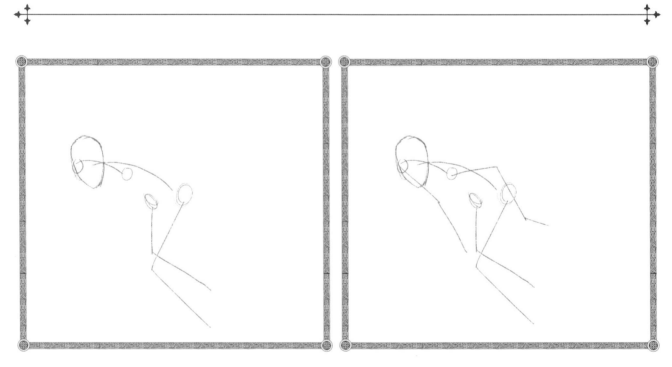

3 Draw in lines for the legs coming from the hip joints drawn in step 1. You are aiming to create a pose that denotes movement and grace in the air. Overlapping the legs like this gives a sense of depth to the figure.

4 Add lines for the arms coming from the shoulder joints drawn in step 2. When positioning the arms, think about how the faerie is hanging in the air – graceful, whimsical and relaxed.

5 Start to flesh out the skeleton by drawing in a simple oval for the ribcage. This overlaps slightly with the head and goes down as far as the far hip joint. Add another smaller oval for the hips keeping this within the hip joint guides.

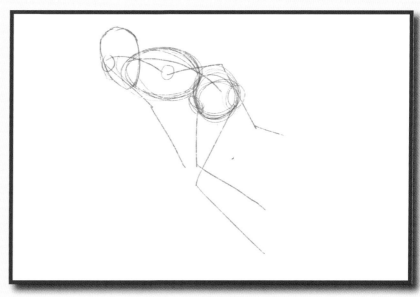

~tip~

Build up the figure slowly, creating a basic skeleton. Keep it simple so that you can easily adjust proportions if you need to – adding detail too soon makes this harder.

6 Add some shape to the legs, following the construction lines. Make the thighs thickest where they meet the body and taper down to the knee. Add a curve to the back of the legs to show the calf muscles and then taper them towards the ankles. You can use a reference photo to guide you if you need to.

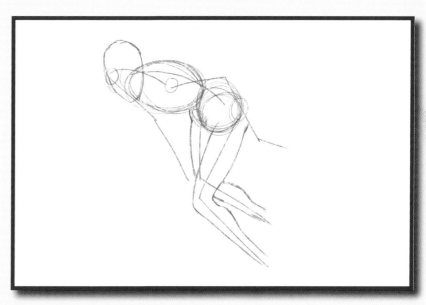

7 Add the feet following the nice line and flow established by the legs. The shape of the feet is important to make the faerie feel graceful and delicate. Draw in elongated triangular shapes with a curve for the heel and tapering to a point for the toes.

8 Add shape to the arms following the construction lines and tapering towards the wrists. Add some simple shapes for the hands to be used as guides for more detail later. Concentrate on the flow of the pose. You want everything to show she's floating with her wings (which will be added soon) supporting her. Her limbs need to trail gracefully, right down to her fingertips and toes.

9 Start erasing some of the construction shapes to simplify the drawing. Gently and carefully rub out the lines that are no longer needed and are becoming confusing. With some of the lines gone you can easily see any mistakes, so take some time to look at the figure shape and lightly refine some of the outlines by pressing more firmly with your pencil.

10 Add a tube shape for the neck. Draw a line to show the curve across her waist area – without this she is a little shapeless, which could hamper the positioning of later shapes and lines. As the faerie is female, add some shape to her chest area.

11 Draw a line down the front of the head to give you the basis for the face. Add a small oval to indicate the position of an ear. Then plot in the shape of the wings, referring to your initial sketches (see page 96). When drawing these, don't press too hard in case you want to erase parts and redraw them.

12 Start to indicate the faerie's clothing. Long tendril-like ribbons are great for adding movement, so draw some in trailing behind the figure. You can design her costume however you like, but making it layered and irregular in shape works well. Try a simple tunic top with some collar detail and a wispy little skirt.

13 Before adding the face, first check whether the head is accurately positioned and proportioned. If it is not, rub it out and redraw it. There's no shame in admitting mistakes. With the head shape, size and position resolved and the centre line redrawn, mark in the eye line – a horizontal line across the face, curved to follow the form of her head.

14 Draw in the rough shape of her eye sockets and the bridge of her nose. Carefully erase the centre line and replace it with a simple nose and mouth. Take a fine eraser to some of the lines around the outline of her head to make them lighter. If the lines are too heavy it will make her head look bulky and inaccurate.

15 Draw in the faerie's eyes – keep them simple, you don't need to get too detailed yet. Draw in a nice rounded hairline on her forehead and add some long, pointed elf-like ears on either side of her head.

16 Start plotting in the hair. Long hair can really add motion to a drawing as well as giving the opportunity for interesting details like plaits and hair decorations. Initially, just draw in the rough shape of the hair and add a centre parting on the top of her head.

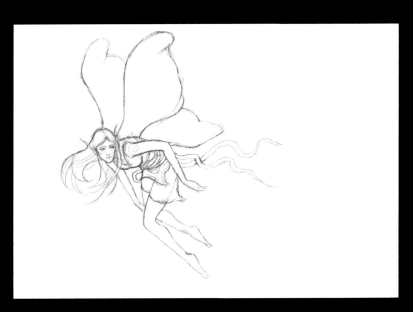

17 Add detail to the hair by indicating some separate strands falling on either side of her head and refining the shape that frames her face. Then, work all around the drawing erasing lines that no longer serve a purpose and making the main lines bolder and more accurate. This will ensure you have a clean drawing to take into the painting stage.

~tip~

The things that make a face look female are a rounded hairline, a tapered jawline and a fine, delicate nose so try to include these features in your faerie line drawing.

18 Go back to your earlier thumbnail sketches and devise the setting for the faerie to be placed in. You don't have to do this if you would rather concentrate on just the figure, but it is nice to put the faerie in an appropriate woodland environment. You could use a photocopier or scanner to enlarge this image if you wish to copy the background directly on to your work.

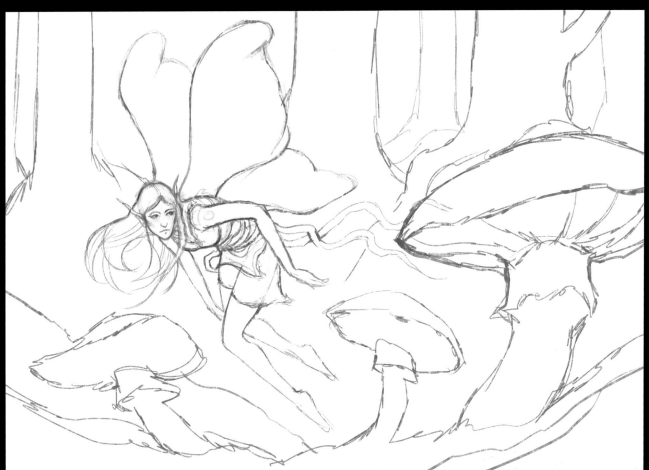

19 With a large brush, lay down a series of washes using a grey-gold colour palette. Work quite randomly, leaving gaps, letting the washes dry then adding more layers to build up interesting textures and effects. Don't worry about destroying the pencil image – this is now only a guide for the painting.

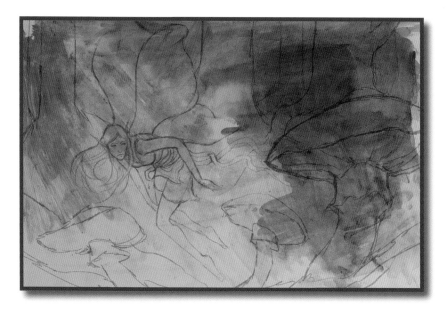

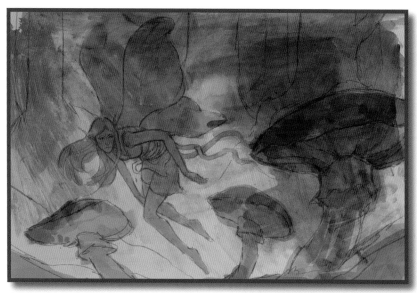

20 Take a yellow-grey colour on the same large brush and wash in the toadstools to give them a bit more presence. Then wash in a warm brown colour on to the toadstools, the foreground and the faerie. Don't worry about being super-accurate, as you will clean up the edges between objects later.

21 Using the same colour and a medium brush, touch in some tone around the faerie to give her some initial form – under her chin, round the top of her head and under her tummy. Add a little bit of wash along her shins, on her hands and at the edges of her wings to give you something to cut back into when you paint the edges later.

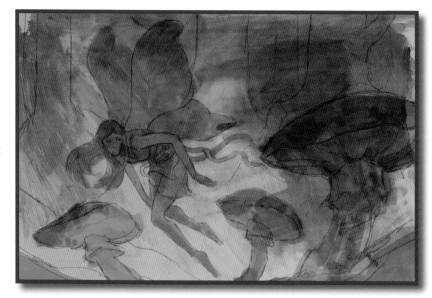

22 Make the faerie and the toadstools stand out more by neatening up the edges with some thinned-down yellow-grey and a medium brush. This will make the interesting textures from the first wash less obvious in the background and more obvious on the figure and will help with depth in the image by bringing the figure forwards and pushing the background backwards. Paint over the pencil outlines slightly so they aren't quite as obvious.

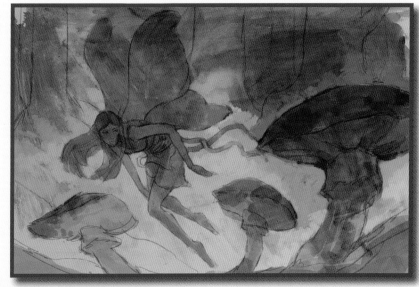

23 Add another wash on the faerie with a browny colour on a big brush. Make her start to stand out even more by putting in some shadows in a greeny colour under her neck and hair, underneath her torso, under her knees, in parts of her hair and around the edges, which you will cut back into at a later stage to neaten them up.

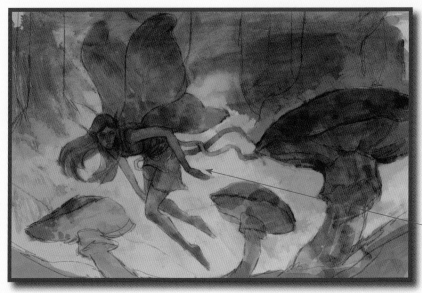

As this is still the underpainting stage, accuracy is not important. Slowly build up the colours that will sit underneath the more opaque paint later.

24 Pick a slightly greeny flesh colour for the skin and paint this on to the face, arms and legs using thinned-down opaque paint and a medium brush so that what is underneath shows through. The aim is to achieve smooth skin where you are painting with this slightly more opaque paint, and lots of textured areas where you are not putting any paint.

When painting the face, let the underpainting peep through where you want shadows or dark areas to remain.

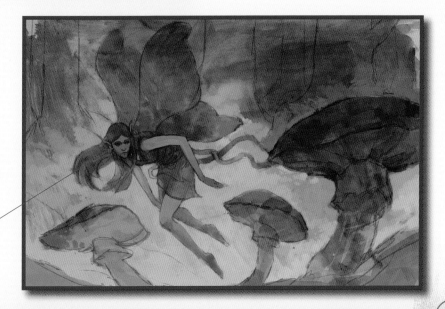

25 Using a slightly lighter shade of the skin colour, add some highlights on the brow, across the cheeks and the nose, along the top lip, and a touch on the chin. Run a highlight along the top of the upper arm and the edge of the forearm with a fine brush. With an even lighter shade of the skin colour, very gently pick out her knee and her forearm on the far arm.

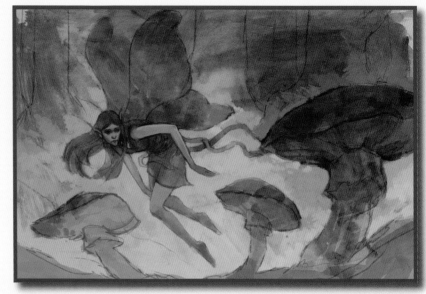

26 The skin looks nice now but the edges are letting it down. Polish up the edges by painting around the forms with the background colour. Let the brush wander a little on the background areas just to suggest some detail – subtle variations and mottling of colours. Using some opaque brown colour, paint out the light sections in the top corners.

Make the corners of the painting darker to hold the eye in the frame.

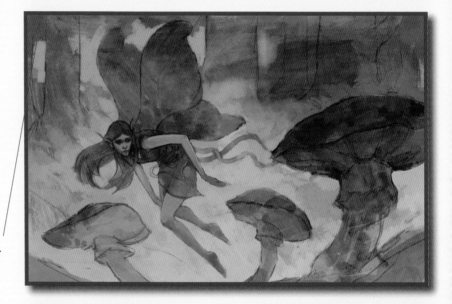

27 Start the wings by splashing on a bold orangey wash – the image will instantly come alive. Go over the first wash with another washy layer of reds to build up a deep, rich colour. Pay close attention to the edges when working with these colours as they will be harder to clean up if you make any mistakes.

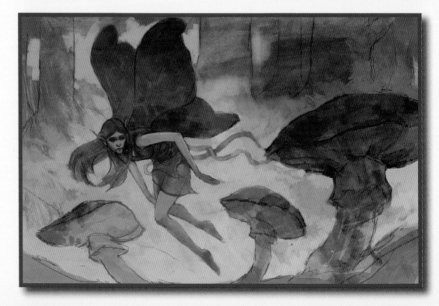

28 Using slightly more opaque paint and a medium brush, add some details to the wings using your reference images as a guide. You don't need to follow them slavishly but they show the patterns and details that real insects' wings have, which will make your image more believable. The pattern on moths' wings is made up of ridges, so try to build this up with long sharp brush marks.

29 Continue working on the wings, adding more markings in browns, very dark browns and oranges observed from your reference images. Then give a final wash to the wings with a big smooth brush to add a shadow running across the top of the nearest wing.

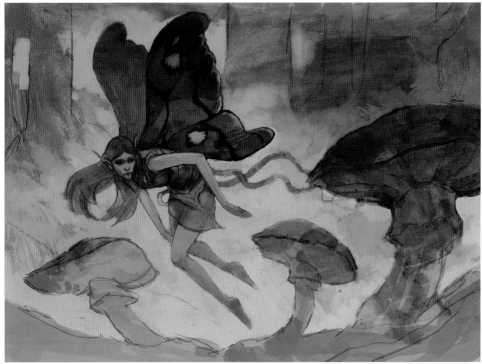

30 Add some highlights to the clothes. Paint in some simple shapes on the clothed areas in a lighter green to give the clothing some form. Add a gentle wash on the clothes with a mid-green colour to bring out the shadows slightly. Go over some of the darker lines with this wash to bring out some detail too. Add some washed-in texture and shape to the ribbon-like tendrils by just dotting some wash about with a small brush, as well as emphasizing where the lines cross.

31 Add a wash of golden blonde colour to enliven the hair. Take some slightly opaque, lighter yellow paint and add in some details. Follow the direction of the hair, round the curve of the head and flowing out. If you keep your paint fairly thin you can build up the highlight shapes layer by layer. Then take an even lighter colour and sparingly add some highlights to the hair.

Hair isn't regular so keep the details loose and varied – don't work in stripes or uniform clumps.

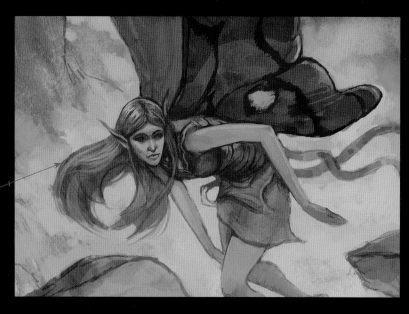

32 Revisit the skin areas, smoothing and neatening the edges with a fine brush and the neighbouring background colour. Add some lighter highlights on the skin areas where the light will be most prominent, like the cheeks, nose, and uppermost surfaces of the arms, following the shapes carefully. Add some fairly dark grey for her eyes and paint in a little bit of dark eyeliner with a fine brush to make her look more feminine.

33 To add life to her face, and to make her look more faerie-like, add a touch of colour with a delicate wash of pink to the nose, lips and cheeks using a fine brush.

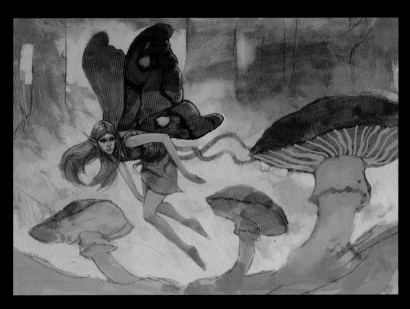

34 Take a break from the painting now and when you come back to it with fresh eyes you will notice things that need improving, such as the toadstool on the right. First, paint some opaque grey around the shapes with a medium brush to simplify it, then add the details of the gill structures under the cap with a fine brush and some grey-brown, referring to your sketches (see page 96). Add a little variation on the stalk with a lighter grey.

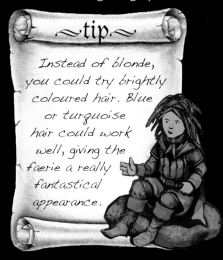

~tip~

Instead of blonde, you could try brightly coloured hair. Blue or turquoise hair could work well, giving the faerie a really fantastical appearance.

35 Give the central toadstool the same treatment as the large one in the previous step. You could spend lots of time on the faerie's hands, feet and other details, but with the focus on her face and everything else in slightly less detail the image is very effective as it is. Add a slightly darker wash to the foreground to frame the image and paint some pale shapes on to the background to show light between the trees – and your enchanting faerie is finished.

Faerie

The Arbour Orb Catcher

To show you what can be done with these relatively simple but powerful techniques, this painting has had more time invested in it to bring it to a more professional finish. In this painting, an airbrush was used to create the glowing effect on the orbs, but this could also be done with thinned-down paint and a normal paintbrush. The background is much more developed here, but still uses the same basic techniques described on the previous pages. With practice and dedication you will be able to use the skills you have mastered across a whole scene, showing the world that your characters inhabit and bringing more atmosphere and magic to your images.

Dragon

This demonstration features a classic fantasy archetype that comes with its own built-in light source – fiery breath! This is the most complex of all the images created so far. As well as designing, drawing and painting a convincing mythical beast, you will also learn about using multiple light sources to create dramatic lighting.

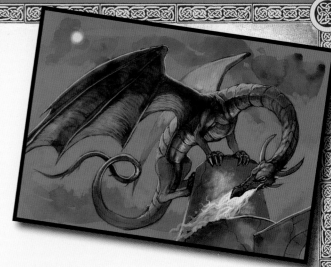

INSPIRATION

To begin a painting of a dragon it pays to spend a little time thinking about the subject. What sort of dragon do you want to create? What could it be doing? What are the important features that you want to include?

Take a look at how other artists have painted dragons in medieval art and modern fantasy art. Do you want to paint a dragon like one you've already seen, or create something more original? As you look through existing paintings, think about which ones you like and what makes each one unique.

REFERENCE

Start to think about what reference images you could find that might help. Lizards instantly spring to mind, as do dinosaurs. Bat's wings could also be useful to look at. If you can, find some photographs of these things and make some preliminary research sketches – your painting will be much stronger for it.

Heads ▶
Lizard heads can provide a starting point for your dragon's head design. Look for photographs on the Internet and draw them out in your sketchbook.

A smooth and sleek outline is very mean and cruel looking.

A spiky outline provides lots of interest but could be confusing to the eye.

▼ Wings
The wings will be one of the most challenging areas of the dragon's anatomy. Drawing from references of real winged animals will help you make them convincing.

Bat wings provide a guide to wing bone structure.

A crane coming in to land reveals how a dragon might look when slowing itself down with its wings.

THUMBNAILS

Grab a piece of scrap paper and make some very quick thumbnail sketches to start to see how you could put some of your ideas down. This can be the hardest part, where you have a blank white page staring at you. Just diving in with some loose thumbnails is really good to get through that. With each new sketch, try to exercise your imagination and come up with something different. Your very first idea might not be the best one you have, and it would be a shame to spend all that time making a painting if you are not using your best idea.

It is the second thumbnail shown opposite that will make the best painting, and it is this that will be used for the step-by-step demonstration on the following pages.

▲ **Thumbnail 1**
Just put down a basic dragon, however it comes out. This sketch isn't bad – depending on how it progresses it could be OK. It fills the space nicely enough, but it's almost dead centre and it's not doing much. In many ways, this first one just has to get on to the paper to allow the better ideas to come through.

▲ **Thumbnail 2**
Think further about what the dragon could be doing. In this case it is landing on a ruined tower. This is great as it lets you put a point of interest over to one side and show the dragon spreading out across the width of the page. The composition, action and pose are good and will show off the wings.

▲ **Thumbnail 3**
A dragon in flight might be a good idea. You can show off the physique and it lets you arrange the beast however you like – spiralling through the air in a terrifyingly powerful acrobatic display. Put the head over on one side to drive the composition.

▲ **Thumbnail 4**
Finally, do something different to what you have already done. Show a dragon hunched over, wings down, looking menacing. The movement will be subtler and you can imagine a dark feel, letting you show the cunning and vicious side of a dragon.

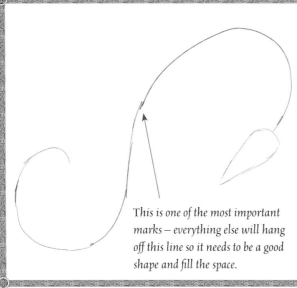

This is one of the most important marks – everything else will hang off this line so it needs to be a good shape and fill the space.

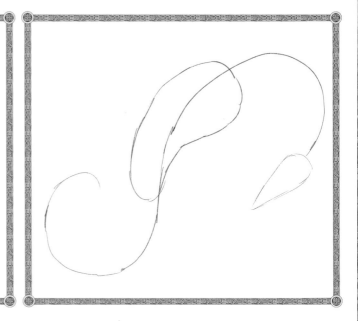

1 Take an HB pencil and begin with a very simple shape for the head, placed on the right. An elongated triangle is a good placeholder shape as it shows the direction the head will point in. Then draw in a line from the back of the head to show the curve of the body.

2 Add a bean shape for the torso. Dragons are quite sinuous, so make his shoulders larger than his lower abdomen and leave space for lots of muscles at the front end of the torso. Follow the curve of the line from the previous step to keep everything on track.

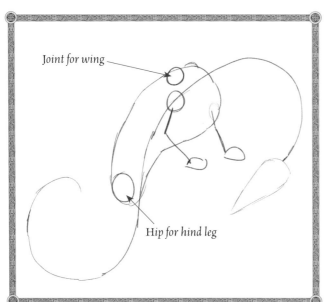

Joint for wing

Hip for hind leg

3 Draw two circles to show where the shoulder for the foreleg and the hip for the hind leg go. Then add some more circles to show where the wing joint and far shoulder will be. Add the forelegs very simply with a couple of lines and two rough paw shapes.

4 Draw in some simple outlines for the wings, starting with the front wing and fitting the back wing behind it. Mark in where the joints in the wing will go. Look at images of bats, winged dinosaurs, or how other artists have handled dragons' wings to help with this.

5 Add some bulk to the neck ensuring it gets thicker towards the body end. Where the neck meets the body, add a line to show the centre of the chest. Add the hind legs working from the circle drawn in step 3 and use another circle to show where the joint in the leg will be.

6 Thicken up the tail in the same way as the neck, making it thicker where it meets the body and narrowing to a fine point at the end. Follow the guide then put a twist in the end of the tail for an extra flourish. Draw in some simple construction lines to show the tower. Make sure that the dragon looks like he is actually standing on the tower by putting its back legs behind the tower and its front paws and head overlapping it.

~tip~

Keep it simple to start with – imagine drawing a foreleg, complete with scales and spikes, only to realize that it's in the wrong position!

7 Add some lines to show the bones in the wing, radiating outwards from the joints. Mark in the centre line of the head and add some slanting eyes, taking care to get them just right. Add in some simple lines to indicate the horns.

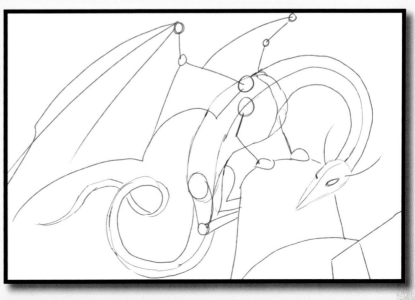

8 Add a diamond shape to the dragon's snout to make more of a beak. Add some bulk to the horns, following your guides then add in another set of horns on the dragon's jaw for extra interest. Use an eraser to rub out some of the construction lines that are no longer needed.

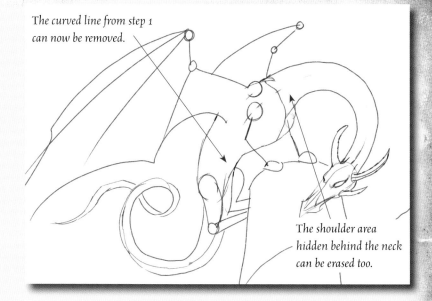

The curved line from step 1 can now be removed.

The shoulder area hidden behind the neck can be erased too.

9 Carefully draw the outline of the dragon's highly muscled forelegs, following the guides. Erase the construction lines from the top edge of the wing and wing joint and start refining these shapes. Add in a line along the dragon's side from the edge of the wing to the hip.

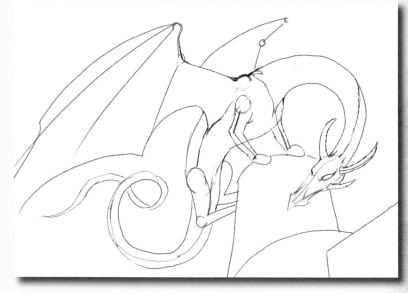

10 Draw in the pectoral muscles on the chest. The centre line you drew on his chest in step 5 helps with this, as it gives you a clearly defined area to work in. Erase the construction lines from the forelegs. Add the missing part of the far wing coming down towards the tail.

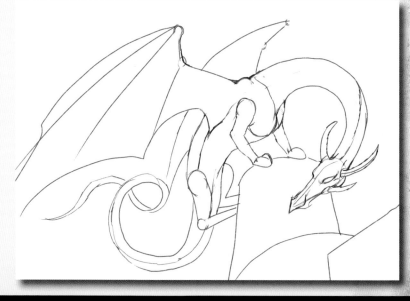

11 Add some bulk to the leading edge of the wing and define the wing joint. Then draw in segments or overlapping plates down the neck and torso of the dragon. Try to imagine the shape of the neck and torso in three dimensions, and trace the lines around that shape to give the illusion of form.

12 Add some more definition and shape to the hind legs to make them look more realistic. Go back to the head and make the outlines tidier and a little more definite. Give the brow a more distinct shape and add lower eyelids to help define the shape of the eyes. Draw a line running down his nose to indicate some kind of bony plate.

13 Continue working on the dragon's head, adding segments to the nose plate to match the neck and torso. Repeating patterns on animals is something that you find in nature, so this will make your creature seem more real. Go over some of the main lines more confidently, by pressing firmly with the pencil.

14 Work up the front claw by breaking up the simple paw shape with three smaller rounded triangles for claws. Start off with simple shapes then refine and add detail to these to make them feel sharp and claw-like. Go back to the wings and add in some more spines following the guides. Then move all round the drawing firming up your lines and making the shapes more definite.

15 Draw in the far claw using the same method as the fore claw. Add a little more detail and definite shape to the tower – some steps and a little detail on the arch – and make sure it is roughly symmetrical. Define the wings by drawing in a series of curves along the bottom edge between each spine. Erase any remaining construction lines in preparation for painting.

16 Using a large brush, cover the sketch with a wash of mid-blue, which will give you a good base to work on. Add some interesting paint marks and effects by splashing on some paint of a slightly different colour and flicking on some splodges of a second wash after the first wash is dry to break up the solid colour and alleviate the flat feeling.

17 Now add some shading (or 'tone') to the dragon. In order to know where the shadows are you have to decide where the light is coming from. Here, moonlight will be coming in from the top left. Begin adding in some tone on to the neck with a fairly dilute wash of deep blue. Continue adding tone to the shadow parts of dragon's body – under its belly, under the wings, underneath the tail, along the side of its head and around its claws.

Use deeper colours rather than darker ones – you don't want black shadows.

18 The underside of the left-hand wing will be completely in shadow, which gives a dramatic dark shape. Paint this in, then also run some shadow under his tail using the same deep blue wash as in the previous step.

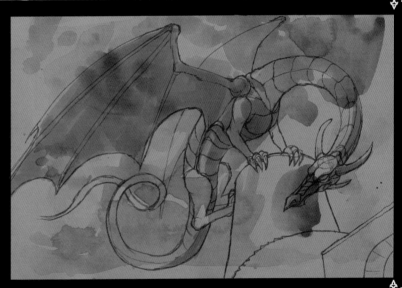

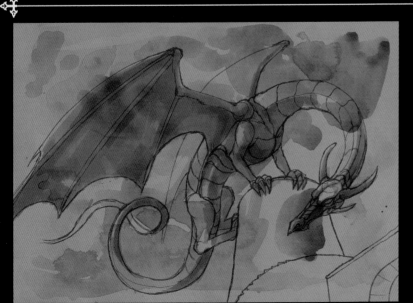

19 Apply another layer of washes with a medium brush on the top edge of the wing membranes where they meet the bones, along its belly, on its forelegs and on its head. This will give you a nice range of shadows, adds texture and interest, and starts to show the three-dimensional shapes. When the first layer is dry, add another layer of washes for the dark shadows in the deepest crevices on the wings, under the belly and where the wing joins the body.

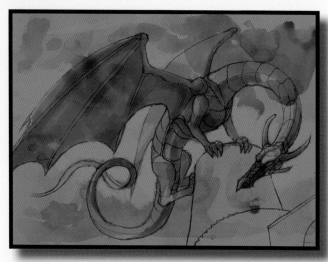

20 Use some opaque mid-blue background colour on a medium brush to neaten up the edges of the dragon and make it stand out against the background. The area around the dragon's head was confusing because of the splodge of paint across it. If this occurs in any areas of your painting, take some opaque paint and carefully paint around the area to clean it up.

21 Go a little darker in some of the shadows, adding in another round of deep shadows with a medium brush, under the wings, under the tail, where the wing meets the body and underneath the belly. By using layer after layer of washes what you actually paint each time is quite simple, but the build-up of layers looks impressively complicated!

22 Paint in some curved lines across the dragon's wings in a deep blue wash on a fine brush to give the impression of wrinkly skin. This echoes the segment pattern across the dragon's body and head that you put in at the sketch stage. Add the moon with a large dot of very pale blue colour and smudge a little halo of light around it with chalk or coloured pencil.

23 With the moon in place, start adding the highlights. Initially, the moonlight falls all along the dragon's back. The effects of direct light are quite strong, so use an opaque paint in a very pale blue on a fine brush. Follow the shape of the dragon's body carefully and try to make the highlights look as if they are sitting on a three-dimensional shape.

24 Continue adding more highlights. Give the edge of the wings a tiny outline of light – this really makes them stand out, but has to be applied carefully with a fine brush and a steady hand so as not to overdo it. Use the same colour as in the previous step to keep the highlights consistent.

25 Put some mid-blue colour on to the dragon's head to brighten it up. The head is not receiving any light from the moon though, so don't use any of the highlight colour. Add more midtones with a finer brush, going over any areas where there is a bit too much dark showing through from the drawing, and making the shapes neater and clearer.

26 Adding in the midtones has made the dragon quite light. You want a nighttime feel with the moon behind him, so put some more tone on, with a bold wash of mid-blue across the wing and round the dragon's body to make him stand out against the sky. Start adding some tone to the tower too.

On the tower, use a big brush and a grey wash so that it does not compete with the dragon.

27 All the washes have left quite ragged edges but you want them to be really crisp. So, take the opaque sky colour and tidy round the outlines with a sharp medium brush. Try to minimize the dark lines of the underlying drawing, which you don't want to be visible in the final image, by carefully painting over them with the background colour.

28 Continue tidying things up with more midtone, making sure your shapes are clear. Add a few more touches of tone here and there along its body and in the wings, adding some little spots of really dark blue around the eyes of the dragon, in the wing crevices and under its belly. Add some more highlights on the tail and the side of the tower.

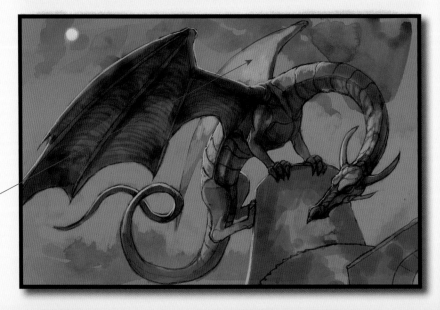

The far wing should be seen in moonlight, so give this a good dose of highlighting.

29 After all the sketching, then adding tone and highlights, you can now start work on the dynamic lighting – coming from the dragon's fiery breath. To start, paint in some opaque yellow with a fine brush to show the position of the dragon's mouth.

30 Very simply add the start of a blast of fire in yellow. If some of the background leaks through that is good – flames can be quite transparent. Think carefully about the spread of the flames as they rush out of the dragon's mouth and block in the basic shape.

31 Paint in a big wave of fire gushing out of the dragon's mouth. You want to see some individual flames, but mostly just a mass of yellow. Build the effect up flame-by-flame, but allowing them to run together into one solid burst. Using a lighter yellow, add in the hot core. Add a little bit of a yellow wash to create some variety of colour in the flames.

A sharp medium brush will allow you to get fine points on the flames, but good width of flame 'body' too.

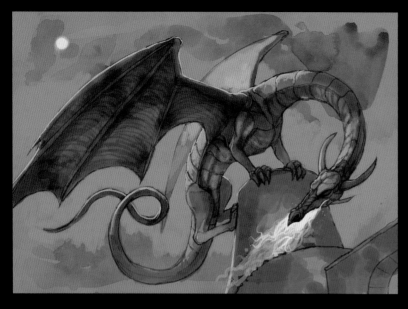

32 Start to indicate where the fire is illuminating the underside of the dragon. This looks difficult but taking it step-by-step it shouldn't be. First, roughly dry brush on some yellow, making sure a fair amount of blue shows through – while the cast light is quite strong it shouldn't be the same strength as the flames themselves.

33 Continue to apply the reflected light colour up the dragon's neck, on the underside of the near shoulder, on the claws, and underneath the tail where it is facing the flames. Then start lighting the wings, which will catch a lot of the yellow light. Show the shapes of what the light is hitting by carefully following the curve of the wings.

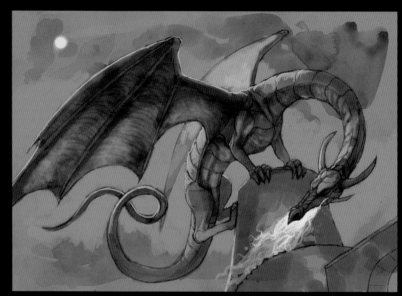

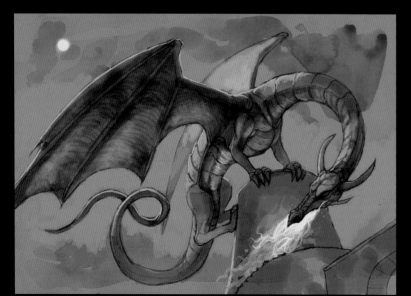

34 Take a lighter yellow and start to pick out some wrinkles on the dragon's belly with a small brush. This adds texture, shows the shape of the dragon and adds detail to the highlights. Continue to apply these ridged highlights all over the dragon's torso.

35 Highlight the spines in the wings with some yellow paint on a small brush. Paint some ribbed highlights across the wings with the same colour and brush, again showing the curving shape of the wing skin.

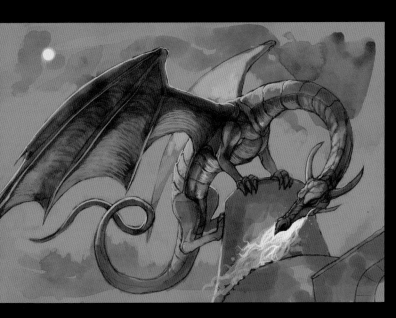

36 Add some highlights on the dragon's face, horns, claws and on the edges of the tower. Paint in his eye in a strong orange colour. Tidy around everything, adding a few more details like the cracks in the tower and a few spines and horns on the dragon with a fine brush and a dark blue colour. Of course, you could continue adding little details and neatening things up indefinitely, but the core principles are now all in place and you have made this fantastic image!

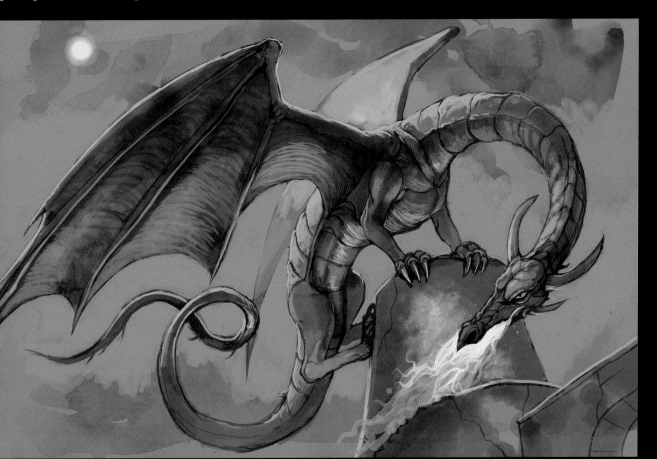

Dragon

Midnight Fire Dragon

With practice and by continued application of deep washes, midtones and highlights, and persevering with your edges and shapes, you will eventually be able to make more polished images like this one. With experience you can expand your images' scope to include more complex settings and finer details. In this painting, the tones are both lighter and darker, which takes more work but produces a high-contrast finish, which really pops the flames. As with all the inspirational images in this book, there is nothing in this painting that is not described in the step-by-step demonstration – it just continues the basic techniques and processes but with more of an investment in time, and the benefit of years of experience … the only magic is practice!

Index

ABOUT THE AUTHOR

Jon Hodgson is a freelance artist from the UK. He trained as a fine artist specializing in gallery painting, and now works full-time in the field of game illustration for both pen-and-paper and electronic games. He has produced artwork for things as diverse as *Dungeons and Dragons* and various other role-playing games, storyboards for children's TV, drawings for TV dramas and paintings for video-game cut scenes. He has done historical illustration, educational anatomical diagrams, labels for bottles of beer and artwork for magazines.

 Jon works largely with digital media, specifically Corel Painter, but was trained in the use of traditional oil and acrylic paint on canvas.

 For more information and further examples of his work visit **www.jonhodgson.com**